THE TECHNIQUES OF CHINESE PAINTING

This comprehensive, beautifully illustrated manual, written by a master painter and teacher in the People's Republic of China, is a unique source of inspiration and authentic advice for anyone who wants to learn to paint in the Chinese manner.

The canons of Western and Chinese painting alike distinguish between formal and spiritual representation, but Chinese painting – mastered by means of a traditional sequence of training that confers rhythmic vitality and disciplined control in the use of brush, ink, and color – aspires chiefly to represent the spirit or essence of the chosen subject.

After a brief historical introduction to the art of painting in China, the author describes the equipment needed, the selection of brushes and ink sticks, the execution of the traditional brush strokes, and the methods of applying color. Thereafter he presents the techniques for creating form, texture, and mood. Separate sections are devoted to landscape painting and flower-and-bird painting, showing in detail the methods and appearance of the differing styles. The text is copiously illustrated with examples in black and white as well as in color, so that the beginner can develop a genuine appreciation and understanding of the art. At that stage, the subtleties of technique can be more easily acquired, and the student grows in confidence and skill.

THE TECHNIQUES
OF CHINESE
PAINTING

WU YANGMU

NEW AMSTERDAM

First published in the United States of America by New Amsterdam Books
by arrangement with The Herbert Press Ltd., London, and
Morning Glory Publishers, 21 Chegongzhuang Xilu, Beijing, China.

This book is an English translation of the 1985 Chinese edition
published by Morning Glory Publishers, Beijing, China.
Editor: Sun Jie
Translator: Gong Lizeng
English text editor: Wang Xingzheng

Designed by Pauline Harrison
House Editor: Julia MacKenzie

The publishers would like to thank Patricia Quested for her
assistance with the English edition.

Set in Fournier by Rowland Phototypesetting Ltd., Bury St Edmunds, England.
Printed and bound in Hong Kong.

New Amsterdam Books
171 Madison Avenue
New York, N.Y. 10016

ISBN 0-941533-88-3 (cloth)
ISBN 0-941533-89-1 (paperback)

Contents

Introduction

HISTORY

Chinese painting has its origins in the pictographs inscribed on bronze during the Xia, Shang and Zhou dynasties (*c.*21st to 3rd centuries BC). Paintings on silk, possessing linear effects, had appeared during the period of the Warring States (475–221 BC) and by the late Western Han era (206 BC–AD 24), paintings in rich colours were being done, such as the murals discovered in Han tombs.

In the history of Chinese painting, figure painting was the first genre to appear. The earliest examples, during the Warring States period, were on silk. (Paper began to be manufactured only in the first century AD.) By the prime Tang (*c.*AD 740–70), figure painting was already well advanced. Mountains, rivers, flowers and birds served only as the background or embellishment of a painting; they developed into independent genres at a much later date. In time, however, landscape painting became the most important genre and numerous schools, theories and techniques relating to it evolved. The earliest extant Chinese landscape is *Spring Excursion* by Zhan Ziqian of the Sui (AD 581–618), an artist who paid special attention to brushwork and used dots and lines as his principal method of expression. Today, many artists believe that a mastery of landscape painting makes it easier to learn figure and flower-and-bird painting because techniques learnt for the former can be used in the latter.

LANDSCAPE PAINTING

Chinese landscape painting flowered during the Song dynasty (AD 960–1279) but its two major schools, Northern and Southern, had originated with the Tang (AD 618–907) artists Li Sixun and Wang Wei (Wang Mojie) respectively. The former, together with his son, created the technique known as *goule* (contour drawing), with rich colours. Wang Wei began the style of bold and vigorous brushstrokes softened by light ink-washes.

Dong Qichang, art critic of the Ming (1368–1644), was the first to define the two major schools of Chinese landscape painting. Though he tended to favour the Southern school and disparage the Northern style, he did put forward some views that were original, objective and constructive. He distinguished the two schools on the basis of the brushwork of famous artists of different historical periods. The brushwork of the Southern, or Literary, school, characterized by a style known as *xieyi* (literally, to 'write ideas'), was supple in general appearance, but the individual strokes were

firm. It is akin to Western Impressionism with free brushwork and little attention to form and detail. Most of today's painters in China work in the style of this school.

In the Northern, or Academic, school, characterized by a style known as *gongbi* (literally 'fine brushwork') and which antedated the *xieyi* style, it was the reverse: the individual strokes were supple, but the overall appearance was firm. It is more like Western realism – meticulous brushwork and close attention to detail. *Gongbi* artists normally signed their paintings 'made by' whereas *xieyi* artists would put 'written by'.

Landscape painting of the Ming dynasty is best represented by the Wu (Suzhou) school. This was a period when Literary painting flourished. Some Ming painters espoused the Northern school, but they had few followers. The six great painters of the early Qing (1644–1911) also all favoured the Southern school.

FLOWER-AND-BIRD PAINTING

Xu Xi and Huang Quan may be the best representatives of Chinese flower-and-bird painting from the era of the Five Dynasties (907–60). The former was noted for his quiet elegance and the latter for his brilliant colours. In the Yuan dynasty (1271–1368) artists such as Qian Xuan and Wang Yuan broke fresh ground with their vigorous but supple brushstrokes and quiet colours, a style that was followed by many later artists. In my opinion, flower-and-bird (and figure) painting can be categorized in the same way as landscape painting, by the brushwork of famous artists of different periods.

Chinese painting, which ranges from strong-colour realism to soft-colour *xieyi*, from meticulous brushwork to free and uninhibited styles, has developed through thousands of years. Traditionally, Chinese paintings have been divided into four categories: animated, skilful, ingenious and natural. An animated painting is one that has successfully captured the spirit or essence of a subject. A skilful painting accurately reproduces the subject's form while an ingenious one possesses the subject's intrinsic charm and appeal. A natural painting has something of the original aura of the subject. I think there should also be a fifth category, called 'crude'. I do not mean clumsy or naive but unsophisticated in appearance because seeking a higher artistic plane.

'Poetic sentiments, picturesque language', 'painting in poetry, poetry in painting' – these are some common sayings on the affinity between painting and poetry. Put another way, a painting must have a soul and that is the artist's original conception. A good landscape painting is one that gives the viewer the feeling that he is actually in it. It should have an ever-present aura. It can be compared to a good portrait in which not only the physical likeness of the sitter is captured but also, more importantly, the spirit.

There are similarities between Chinese and Western painting as far as types of brush mark are concerned, but the two are very different in their methods of presentation. In both Chinese and Western painting, a distinction is made between formal likeness and spiritual likeness, and in both formal likeness is achieved first. But Chinese painting has long freed itself from the constraints of form and shifted its focus to the spirit. However, the process of mutual assimilation between Chinese and Western styles has been going on for at least a thousand years; it is a matter of international cultural exchange as well as an aesthetic problem and is, of course, on-going. No doubt new schools and styles will appear in Chinese painting in the future.

ELEMENTARY TECHNIQUES

Chinese brush skills have been tempered, tested and improved from generation to generation until they have reached a stage of near-perfection. The student is advised to think and plan carefully before taking up the brush. As a rule, when painting a landscape, the nearer objects should be done first and the trees before the rocks. All these should be done in ink, to which colour may be added later. However, if the scene is satisfactory in ink alone colour is not necessary. Flower-and-bird paintings can also be executed in ink alone or in both ink and colour; or they can be done in colour alone without any ink.

The standards still generally used to judge the quality of paintings and guide the student are the six principles formulated by Xie He (Hsieh Ho) of the Southern Dynasties (420–589 AD): 1. spiritual and rhythmic vitality 2. disciplined brushwork 3. proper representation of objects 4. true colouring 5. good composition 6. copying old masters.

In my opinion, having learnt how to handle the brush (*see* p.19), you should begin by copying old masters, from which you can learn 'disciplined brushwork' and traditional techniques. It is better to copy simple paintings first and proceed gradually to more intricate ones, to copy parts of paintings before attempting whole works, and to copy paintings of the realistic (*gongbi*) school before learning other styles. If you begin with paintings in bold, impressionistic style or in splashed ink, which may seem easier because they tend to ignore details, you may acquire some general knowledge of painting but will not have a chance to study its finer points. For you must learn thoroughly how to do a proper representation of objects and be versed in the many forms of 'disciplined brushwork'. Inadequate training in these areas will be a great handicap later on. To sum up, I suggest you start by working hard at making copies.

After some time, while continuing to copy the old masters, begin doing sketches from nature. On the one hand, you should make bold 'transplants',

assimilating into your work the good points you have learnt from the old masters. On the other hand, you should give full play to your own creative ability, and learn the art of 'good composition', which means the proper arrangement and positioning of objects in a painting. Your first sketches may not look right, but you must persevere in the spirit of a pioneer. Otherwise you will only know how to make copies and your ability to create will be stunted.

Some people say that a student should learn from only one school of painting. I do not see any harm in learning from more than one school; this allows you to assimilate the best of each and, in time, cultivate your own style. If someone asks, 'Are there any tricks of the trade?' my answer is that the only trick is to practise hard and constantly review what you have learnt.

The Four Treasures of Chinese Painting

Paper, ink, inkstone and brush (FIGS i & ii) are commonly called the Four Treasures of Chinese painting. They are the most important tools and materials used in traditional Chinese painting and calligraphy. In painting, a fifth treasure, pigments, should be added.

PAPER

The principal kind of paper used in Chinese painting is *xuan* paper, so called because it is made in Xuancheng in Anhui province. In the West, *xuan* paper is commonly known as rice paper. It comes in three finishes: sized, semi-sized and unsized. Sized *xuan* paper is coated with a solution of alum, which renders it less absorbent and therefore makes it easier to control the ink. It is best for landscape and flower-and-bird paintings in the *gongbi* style. Semi-sized *xuan* paper is treated with thin rice gruel or soya bean milk diluted with a great deal of water so that it remains absorbent but not as diffusive as unsized paper; ink and colours applied to it have a smooth and lustrous appearance. Unsized *xuan* paper is used for landscape and flower-and-bird painting in the *xieyi* style in which some degree of diffusion is an advantage.

Xuan paper is manufactured in sheets of standard size. In China it is sold in various forms: scrolls, couplets, sets of four (for doing panoramic scenes) and in long rolls made by joining sheets together. When selecting *xuan* paper, hold a sheet up to the light. If you see cloudlike patterns, it means it contains much cottony material and the paper is of good quality. Another test is to hold the paper in one hand and shake it; if it is good quality it will emit a crisp sound.

When practising, you can use sized 'moon' paper, which is available in rolls from China and Japan, and *maobian* paper, made from bamboo. But once accustomed to painting on *maobian* you may find it hard to paint on *xuan* paper, which is more absorbent.

Gold paper (gold particles sprinkled in the texture) can be used for variety and special effects. It is available in different colours, blue, pink and lemon for example.

For interest, I mention here other papers which have traditionally been used in Chinese painting but are not necessarily available in the West or used much in China today. *Pi* paper (literally, leather paper), made from bast

fibres, has been used in landscape painting for centuries. It is a tough paper with similar properties to semi-sized *xuan* paper, but is softer. *Fa* paper (with hair-like patterns in the texture), chalk paper (coated with powdered chalk), *gaoli* paper (originally made in Korea, it was often used to paper windows in old-style Chinese houses); these papers are non-absorbent, often smooth and glossy, and do not take ink easily.

Paper not in use should be wrapped up and stored in a cabinet. Precautions should be taken against mildew, which causes clusters of non-absorbent dots to appear on the paper, and against damage by wind and rain. In China, mounting shops work with windows tightly closed even in summer.

Silk can also be used to paint on, but is more suited to *gongbi*-style paintings. Today, it is treated with alum first. Gauze was also used by the old masters, but if used it must be sized because otherwise the ink and colours would soak through.

Ink

Ink is very important in Chinese painting. There are various kinds of ink, but the best type for painting is soot ink made from carbon and mixed with glue. It is black and lustrous; even light tones rendered with it have a spirited appearance. The darkest ink is lacquer soot ink, of which the chief ingredient is lacquer; it is used to depict the prominent parts, the 'highlights', of a painting, but should be used only in moderate amounts.

Chinese ink is solidified and supplied in the form of small sticks, which are easy to store and handle. Liquid ink for writing and painting is prepared by grinding an ink stick in clear water on a stone slab called an inkstone.

The best ink sticks are fine grained and low in glue content. They have a slight bluish-purple tint and a fresh odour. Though old ink sticks are often of better quality, the glue tends to deteriorate with age, causing the surface of the stick to crack and tiny bits to flake off. To prevent or slow down this process of deterioration, ink sticks should be kept in a dark, dry place.

You should only grind as much ink as you need at any one time. The ink stick should be held perpendicular to the inkstone with one hand; it should not be allowed to slant. A large ink stick can be capped with paper to avoid staining the fingers during grinding. (The old Chinese adage, 'an ink stick can be ground at both ends', is only a joke, not a technique to be used in practice.) Surplus ink left overnight is never very good, except when you want to create a particular effect (*see* p.23). If the weather is not too hot, it may not make much difference, but when painting on fans, gold paper or silk, only fresh ink should be used.

The consistency of ink may be varied in order to give different shades of black. The five most common shades of black, or ink consistencies are:

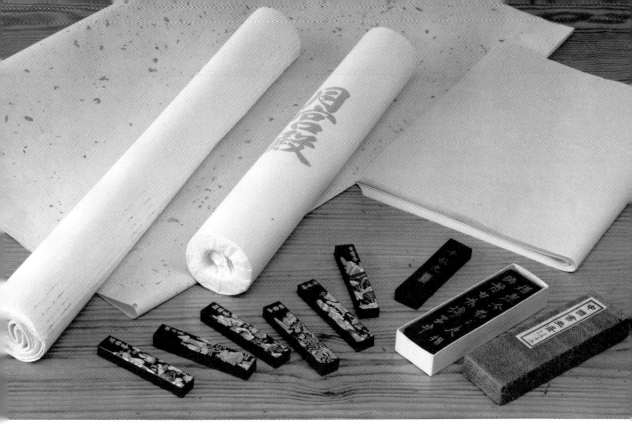

FIG. i Paper: (left to right) gold, *xuan*, moon, *maobian*; ink sticks

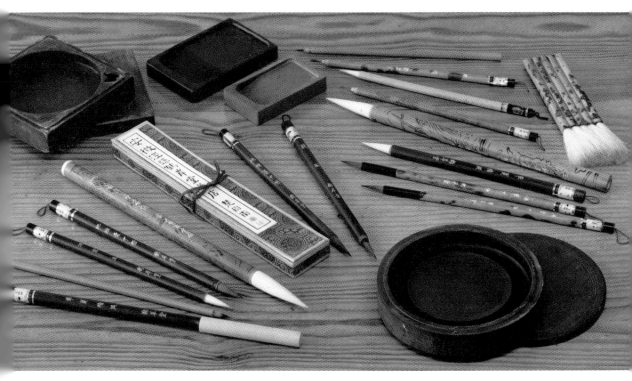

FIG. ii Assorted brushes and inkstones (two with lids)

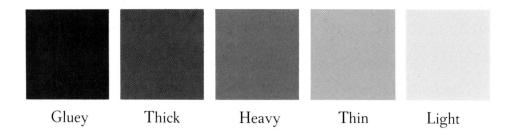

| Gluey | Thick | Heavy | Thin | Light |

Concentrated, or gluey, ink (*jiao mo*) is made by grinding the ink stick on an inkstone with a few drops of water until the water becomes a thin paste. Thick ink (*nong mo*) is slightly diluted gluey ink. Heavy ink (*zhong mo*) contains a greater volume of water than ink paste. Thin ink (*dan mo*) contains several times more water than ink paste. Light ink (*qing mo*) is made by adding just one or two drops of ink paste to a cup of water; when brushed on paper, it is barely discernible.

Ink is also now available from Japan in liquid form, but is no substitute for freshly ground ink. Liquid writing ink is not suitable for painting.

INKSTONES

Two kinds of inkstone are available: round with a lid and a hole to drain off the ink not used, and rectangular with a slope. These come in various sizes. Do not get one too small otherwise you will not be able to grind enough ink at any one time. Liquid ink ground on a good inkstone is thick but smooth and flowing.

Ink left overnight on an inkstone will clot, so the inkstone should be washed frequently to remove the clots. The ink stick should never be left on the stone after grinding because it contains glue and will stick to the stone if not removed right away. If this does happen, however, do not remove the stick by force as this may damage the surface of the stone. Pour away the liquid ink, then splash some hot water on the stone, once or twice, and the stick will come off.

BRUSHES

Brushes vary according to their function. There are brushes for landscapes, for flowers and birds, for *xieyi* paintings, and for *gongbi* works. There are three main qualities: soft, stiff, intermediate, and they come in a range of sizes. They are made from the hair of an animal – goat, rabbit, wolf, weasel, horse – or a combination of hair. Brushes made of goat hair are soft, pliant and non-resilient; because of their pliancy, they are good for spreading ink and applying colour washes, and they are indispensable for painting flowers and leaves. Rabbit hair is slightly stiff. Wolf hair is stiffer, highly resilient and is the most versatile; it is ideal for painting landscapes, and,

in brushes of a different size, for painting orchids and bamboo. Horse-hair brushes are used to produce a rough, dry line.

A large area in a picture, such as the sky or sea, is sometimes painted with a number of brushes fastened together in a row, called a *pai bi* (row of brushes). Some strokes should be made with a stump brush (FIG. v), made by slightly searing the tip of a new brush in a flame.

There are no fixed rules governing the length of hairs in a brush. Long and short tufts can be used equally well, so it is largely a matter of preference. However, the handle, or stem, of the brush should be relatively long, with about one third of the length of the hairs inserted into it to ensure a firm grip. The quality of a brush can be tested by soaking the tuft in water and spreading out the hairs. The hairs on a good brush spread evenly at the tips. New brushes are sized to maintain their shape and must be soaked before use. Because of the sizing, it can be difficult to determine the quality of a brush in the shop. Good-quality brushes are essential and the price usually tells you this. The higher the price, the better the quality.

A new, unused brush can be stored with the cap removed if mothballs or camphor powder are placed nearby. After use, the brush must be washed clean and dried with paper, then hung on a rack, or stored wrapped in a bamboo mat.

PIGMENTS

Traditionally, the colours used in Chinese painting are made from mineral and vegetable pigments. Today, pigments are sold in tubes which are both easy to carry and convenient to use. However, the solid colours sold in chips or as cakes in ceramic dishes are more economical. The chips should be dissolved in sufficient warm water so that the colour has a smooth and even appearance when it is applied. Yellow is an exception – it is made from the congealed resin of the sub-tropical rattan plant; it is poisonous and should be used with care. It is not necessary to dissolve the lump of resin when you are painting; just pass a wet brush over it. Remember to use a different brush for each colour.

Colours are also available in boxed sets of sticks of colour (like the ink sticks) but you will need many inkstones to grind them upon. If you find it difficult to obtain Chinese colours, whether it be the tubes, chips or sticks, you can substitute Japanese colours which are more widely available, although some of the colours are slightly different. Western watercolours and gouache colours can also be used. Students can use Winsor and Newton Cotman water colours and progress on to the more expensive Artists' water colours (FIG. iii).

The basic colours for Chinese painting are as follows: indigo, rattan yellow, umber (raw and burnt), rouge, carmine, cinnabar, mineral blue,

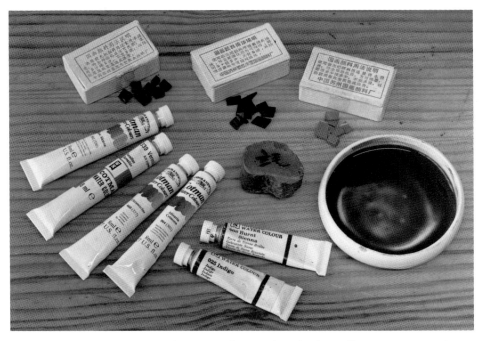

FIG. iii Colour chips, lump of rattan yellow, cake of colour, Cotman water colours (front left), Artists' water colours (front centre)

mineral green, lead white. Some western alternatives are: indigo, ultramarine, cadmium yellow, yellow ochre, raw umber, burnt sienna, alizarin crimson, scarlet vermilion, cadmium red, viridian, Chinese white.

OTHER EQUIPMENT

A bowl, with or without partitions, for washing brushes or holding clear water. White bowls are best (FIG. iv).

A colour-mixing basin, large and heavy enough to remain steady when a brush is stirred in it. Again, white is preferable (FIG iv). Plates and trays with partitions for mixing colours; small cups for various uses.

Plates for storing colours; these have lids and can be stacked (FIG. iv).

Brush racks, paperweights, brush holders. Racks have indentations for several brushes and are made of mahogany (FIG. v). When painting outdoors, it is best to wrap your brushes in the bamboo mats used for storage (*see* p.15), so that they will not wet or soil the other items in your kit (FIG. vi).

Some painters like to place a piece of felt under the paper on which they are painting (FIG. vi). This is all right for a quick painting in the *xieyi* style, but for an elaborate *gongbi* painting that takes a long time to finish, the felt may discolour the paper. A sheet of white paper inserted between the felt

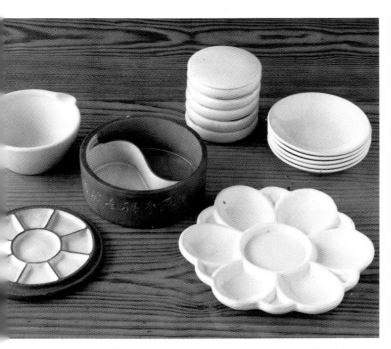
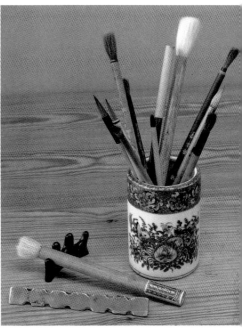

FIG. iv Two bowls for water (one with lid), plates with lids for storing colours, plates for mixing colours, colour-mixing basin (front right). FIG. v Brush holder, brush rack (with stump brush), paper weight (can also act as brush rack)

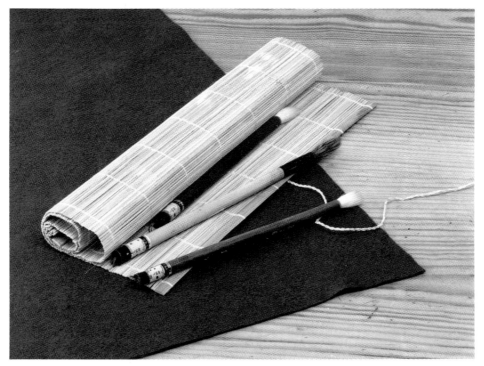

FIG. vi Felt; bamboo mat for wrapping brushes

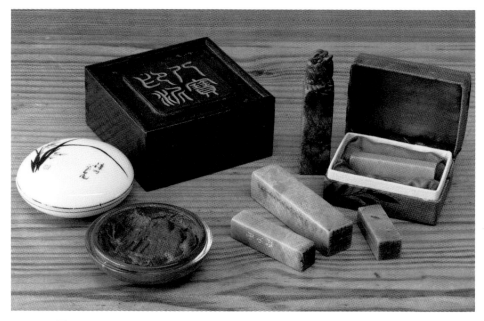

FIG. vii Two containers of red ink paste (one with box), seals (one with box)

and the painting paper will prevent this. Newspaper can be used instead of felt, if need be.

A painter should also keep on hand seals and red ink paste. The seal stands for a name or phrase and you can have one carved. The seal is usually supplied in a small case and the paste in a porcelain container (FIG. vii). The ink paste is usually reddish brown or bright vermilion. When using the seal, make sure that the red ink is spread evenly over the surface. Press the seal down quickly on the painting, but lift it up slowly. After use, wipe the seal clean with a piece of soft cloth before putting it back into the case. If you use more than one seal, it is better to keep each one in a separate cloth or paper bag, with the upper part of the seal exposed for easy identification. (*See also* p.128.)

Chapter 2
Landscape painting

CHOICE OF STYLE

People who want to learn Chinese painting often do not know where to begin. They may have heard about different schools and styles, but it is difficult to decide which one to follow. It is therefore advisable to make comprehensive studies to find out what your preferences are: fine or vigorous brushwork, a serious or a subtle style, subdued or brilliant colours. You should rely more on your own judgement than the preferences and practices of others. The choice of style is important and should be made with care. Although the usual process of study is from the easy to the difficult, from the simple to the complex, exceptions can be made if a student's skill and understanding develop quickly.

USE OF BRUSH, INK AND COLOURS

The techniques of Chinese landscape painting are numerous and diverse, largely because there is so much variation in the brushwork. This is why disciplined brushwork is a very important principle. Disciplined here means the combination of strength, rules and order in the use of the brush. To achieve such an effect the artist's feelings must harmonize with the brush in his hand.

In order to use a brush well, you must first learn how to hold it properly. To make it easier to follow the instructions, let us assume that the brush stem has four sides – left, right, front, back – though it is actually round.

Press the left side of the stem (the side nearest to you) at about the midpoint with the tip of the thumb, and let the opposite (right) side rest against the second joint of the index finger. Bend the index and middle fingers so that their tips rest against the front of the stem. Place the first phalanx of the third finger against the back of the stem, with the little finger nestled up to it but not touching the stem. The brush is now held in place.

When painting, move the thumb forward or backward to rotate the stem; use the third finger, with the aid of the little finger, to push the stem outward and the index and middle fingers to draw it inward (FIG. viii). The strength is all in the fingers. The palm should be cupped as if holding a round object. Do not grasp the stem too tightly or you will not be able to manipulate it easily; what is required is not sheer physical force but strength used skilfully and harmoniously so that, through concentration and correct

manipulation of the wrist and fingers, it will be transmitted to the very tip of the brush. Strength applied in this way is so effective that in the past it was said: 'the strength of the brush is great enough to penetrate through the paper' and 'the brush is as powerful as a diamond pestle'. There are, however, exceptions – as when doing the finger-flicking texture strokes, which are executed by means of an elastic movement – a flick – of the brush tip on the paper. Here the grip must be altered because in order to flick the brush the fingers cannot rest firmly on the stem, though the same concentration is required on the part of the artist. This is why we say that though there are rules for holding the brush, they are not hard and fast.

A stroke made with the brush held vertically and moved steadily across the paper is called a *zhong feng* (centre stroke, FIG. ix). One made with the brush held obliquely so that the side of the tuft is used, and with variations and turnings, is a *pian feng* or *ce feng* (side stroke, FIG. x). One made with the brush vertical and the tuft in reverse position i.e. with the hair tips in front, is a *ni feng* (reverse or counter stroke, FIG. xi); this kind of stroke, which is usually very short, is often used to paint moss. A stroke whose course can be easily traced is a *lu feng* (open stroke). Its opposite, for example a dot, or a straight line with no clear direction, is a *cang feng* (concealed stroke). A stroke that ends with a slight reverse movement to check the momentum is a *hui feng* (return stroke). When the brush tip barely touches the paper and is raised again, it is called a *dian* (dot) stroke. A stroke made somewhat heavily with a stump brush is called a *zhuo* (tap) while one made with the brush held vertically, then lowered obliquely, is a *zuo* (drag).

Other points concerning brushstrokes should be mentioned: for trailing strokes use a wet brush and for sweeping strokes a dry one. Hold the brush vertically when drawing lines; use the side of the tuft for thickening; use the tip for tracing, a short tuft for pressing, a long one for doing the contour or outline. There are also many kinds of strokes for doing texture lines. Spreading washes on paper with a wet brush is called *xuan* (washing); *ran* (dyeing) means spreading a wash over a smaller area.

When doing a small painting, you can rest your wrist on the table and move just the fingers. When doing a medium-sized one, raise the wrist but keep the elbow on the table. For a large painting, you may have to stand up so that you can move your arm freely. And for a very large one, stand with your feet apart so that you can bend easily and get a longer reach. Very large paintings are usually done by pinning the paper on a wall and using a large brush.

Some landscape artists use brushes with short tufts; others prefer long tufts. Both can produce good work provided the brush is handled well.

A dry brush produces the downy appearance that is so important in landscape painting because it creates an impression of vastness, distance and

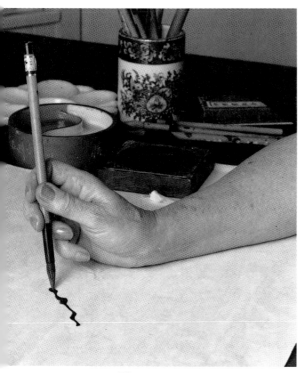

FIG. viii How to hold a brush

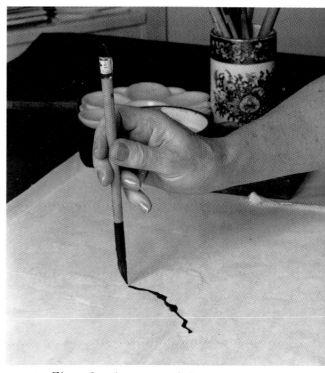

FIG. ix *Zhong feng* (centre stroke)

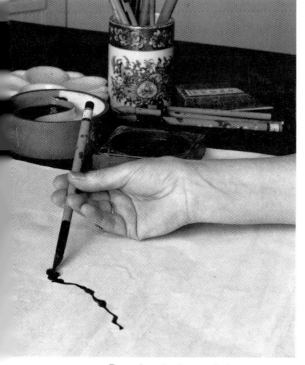

FIG. x *Pian feng* (side stroke)

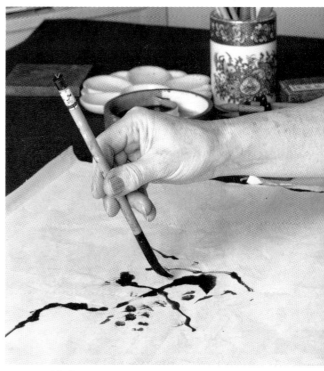

FIG. xi *Ni feng* (reverse or counter stroke)

depth. Not only contours and textures but also dots and trees – distant or near – should be downy, for it is the combination of all these that produces the desired effect. A wet brush can also produce a downy appearance, if the ink is allowed to soak through the paper or the brush is dragged slowly on silk. The results are just as good. The beginner is cautioned against using one kind or pattern of strokes throughout, as this will create a monotonous atmosphere. A dry brush that is not used well will also give your painting a dry or dull appearance.

There is an ancient saying: 'The beginning calls for courage; the end demands care'. The first of these statements means that when painting, you should not be overcautious; once you have given sufficient thought to the composition of your painting, start to work with a will. The second refers to the finishing touches, which are comparable to a gardener's trimming and pruning of full-grown trees and bushes.

Whatever method of painting you use, whatever the image, every stroke should be both firm and flexible, though in varying degrees. A faulty stroke should be corrected immediately by a new stroke; if not corrected, the fault may spoil the whole picture.

The ink and brushstrokes in Chinese painting are, respectively, like the flesh and bones of a human. Only when both function perfectly can the form and spirit of an object be properly represented. The ink should be applied to paper like lacquering, that is, in strokes that are quick but firm and steady. A stroke that slips is a faulty one.

When using ink you should understand and bear in mind what is implied by the following lines:

Li Cheng uses ink sparingly like gold;
Wang Qia splashes ink when he paints.

Some beginners seem to be afraid of using sufficient ink; others splash it thickly all over the paper. The first is not an example of sparing use of ink; nor is the second a demonstration of the splash-ink method. Using ink sparingly and splashing it are two important techniques of Chinese painting, to be used according to the needs of the picture and brushwork. A good painting can be done with very little ink or with plenty of it, the crux of the matter being how to use the ink properly, in the right amount and at the right place. Inking is a skill that can be mastered only through hard study and practice.

Two other inking techniques are known as 'accumulation of ink' and 'breaking'. The former means applying thin ink in layers, a new layer being added either before or after the previous layer has dried. 'Breaking' is to break the flatness or plainness of a picture, or some parts of it, with dabs of

thick or gluey ink. Dry ink strokes can be broken with wet ink and vice versa.

A basic rule in the use of ink, generally followed by the Southern school, is to proceed from thin to thick. The Northern school, however, uses thick and thin ink alternately and sometimes starts with thick ink.

The relationship between ink and water is a subtle one. The amount of water added to the ink determines the degree of diffusion of the mixture: the more water, the greater the diffusion. Gluey ink, though it also contains water, is too thick to diffuse even when brushed slowly across unsized *xuan* paper. When water is added to overnight ink (i.e. ground the day before or several days before) and the preparation is used before the ink and water have fully mixed, an interesting phenomenon appears: the brushstrokes are clearly distinguishable but the ink diffuses beyond the edges of the strokes.

Ink sometimes acquires a greasy appearance. This may be due to applying too many layers of ink, but is more often the result of making too many corrections on the same spot. When the greasiness appears, do not add more ink or try to make further corrections; and do not paste over the faulty spot or tear up your work and start again. Proceed with another part of the painting. When the whole landscape has been completed, the greasy spot, overshadowed by the rest of the picture, may no longer seem greasy and may even need a few more strokes of ink.

In Chinese landscape painting, colour is added after the ink. There are two principal colours in Chinese landscapes, reddish brown and bluish green, which are rendered chiefly by the pigments umber and mineral green respectively. There are numerous shades of reddish brown, relatively few of bluish green. Colours are seldom spread evenly in landscape painting. The first layer of colour should be fairly light, with additional layers applied gradually where necessary. If too many layers are applied, they may overload the *xuan* paper and obscure the ink, giving it a dull greyish appearance. A painting dulled in this way cannot be remedied, so always take care that the colours do not overshadow the ink, nor the ink the colours.

Before applying colour, you should have a clear idea of how you want the finished picture to look – for example, whether it is to be a spring, summer, autumn or winter scene. For spring and summer, green is the best principal colour; for autumn and winter, it is umber, unless the subject is a snow scene. The principal colour must be decided before selecting the auxiliary or supporting colours. There may be many auxiliary colours, but the principal colour must predominate.

The pigments used in Chinese painting differ from those used in the West. Chinese colours are less brilliant, quieter and more subdued. Nowadays, to heighten the brilliance of their works, Chinese artists sometimes use Western pigments or a mixture of the two.

The combination of colours has been a subject of study in Chinese painting since ancient times. *On Painting*, a monograph by Jing Hao of the Five Dynasties (AD 907–60), contains some pithy sayings on this subject:

Red and yellow – falling leaves in autumn
Red and green – flowers in bloom
Pink and yellow – greater splendour
Blue and purple – colour of death

While some of these sayings may be true and some may require further study, the importance attached to colour by painters in ancient China cannot be denied. An artist who is skilled in using colours can achieve cool effects with warm colours and warm effects with cool ones, let alone the numerous variations that are possible with colours of the intermediate range. Blue and purple mixed, for example, may produce a cold colour but, when used in the right place, it can enhance the tranquillity of a mountain forest scene or the attraction of a white flower with pale leaves.

There are many ways of applying colour; the following are the most important.

1. *Dian ran* (dots and washes). Tree leaves and moss can be dotted in ink; rocks can be painted with washes. Traces of the brush are visible in dots, not in washes.
2. *Hong yun*. This is like *xuan ran* (large washes). It means spreading washes in light colours over a large area, a method used to depict clouds and mists.
3. *Gou ca* (going over). If after several layers of colour have been applied the ink and colours are still not clearly defined, going over certain parts with a thick colour will make them stand out. Umber and mineral green are the usual pigments for this purpose.
4. *Pu di* (priming). The paper can be primed with a well-diluted colour wash before applying colours; a method used when the desired richness of a colour cannot otherwise be obtained.
5. *Zhao se* (undercoating with alum). When the colours run too easily, coat the paper thinly with a solution of alum, but do not apply any more colours until the solution has dried.
6. *Tuo di* (coating the back). To make the colours rich but not greasy, coat the reverse side of the paper with white or some other colour. This method is often used in *gongbi* painting.
7. *Shen hua* (seeping and diffusing). You can make a colour seep or diffuse deliberately; a method often used in *xieyi* painting.
8. *Tian qian* (filling in). More spirit can be given to a *gongbi* painting executed in strong colours, by adding more colour.
9. *Bei fu* (colouring the back). Colours are sometimes applied to the back of

the paper or silk. When viewed from the front, they present a very uniform appearance.

10. *Fei se* (flying colours). When all the colours have been done, various diluted liquid colours can be quickly brushed over the surface to give an even greater variation of colour.

Techniques: 'gou-le' (delineating) and 'cun-ca' (texture lines)

Before and during the Sui dynasty (AD 581–618), hills, mountains, rocks, trees and water in Chinese landscape painting were depicted with dots and lines only. *Cun-ca*, an important advance, did not develop until the Tang dynasty (618–907). The literal meaning of *cun* is 'to chap', to cause the skin to split and roughen. In Chinese painting, it refers to doing texture lines that resemble chapped skin, on mountains, rocks, the bark of trees, etc. There are many ways of doing these. The texture of mountains differs according to their compositions. Even rocks on the same hill or mountain may vary; and a single rock may not have the same texture throughout. In general, however, the peaks, ridges and rocks of any one mountain have the same or similar basic texture, and the method of painting texture lines should be selected according to this. Experience tells us that the distinguishing features of a landscape can be well expressed if the texture is done in the right way; trees and flowing water play only a secondary role in such paintings.

Cun and *ca* are two kinds of brushwork, closely related. *Ca* (rubbing) is supplementary to *cun*, and the two are often used in conjunction with each other. When both *cun* and *ca* strokes are used effectively you will have achieved 'rhythmic vitality', the first of the six principles of landscape painting (*see* p.9), and the beauty of the landscape will be much enhanced.

Gou-le is the technique for doing outlines, or contour lines, (FIGS 1–4) – the 'bones' – of rocks and hills. These lines break or divide the rock or hill into three or even four or five surfaces, creating a three-dimensional effect.

When painting a rock, do the contours first, by *gou-le*, then add the texture by *cun-ca*. This is the usual way, but sometimes the painting can be done in the reverse order, the texture first, and sometimes texture and contour lines can be done alternately, as required. Sometimes, *cun-ca* can do the work of *gou-le* and vice versa, depending on the preference and practice of the artist.

Gou and *le* are two kinds of brushwork. *Gou* is to trace or delineate and *le*, literally, is to engrave and inscribe. *Le* is supplementary to *gou*, as *ca* is to *cun*; it means going over some of the *gou* lines. *Le* strokes should be made resolutely but carefully; short strokes are preferred. When a *gou* line has been well drawn and needs no going over, *le* strokes are unnecessary. Some people say that when doing mountains and rocks, *gou*, *le*, *cun* and *ca* must all

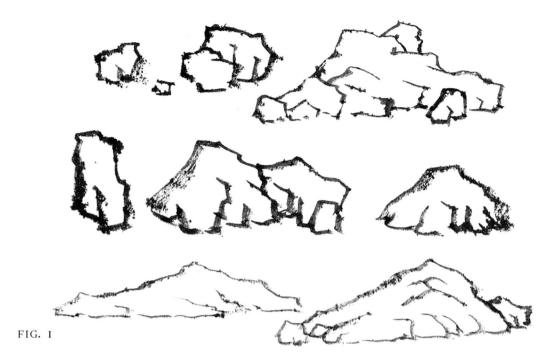

FIG. I

be used. This is not true. Fine landscapes have been done with just *gou* and *le* strokes, but in such cases *gou* and *le* must create the effects of *cun* and *ca*.

Gou and *le* are usually made with a wolf or rabbit brush. The general rule for doing a contour line is to start on the left and move upwards and to the right. Hold the brush at an angle of 45–50° to the paper when you begin, and rotate the stem inward with the thumb as you move along until it is vertical. Complete the outline of a rock, or other object, in one stroke. The line marking the base of a rock or hill should be done lightly; in fact, it can be omitted so that a sandbank, flowing water or other rocks can be added there.

FIG. 2

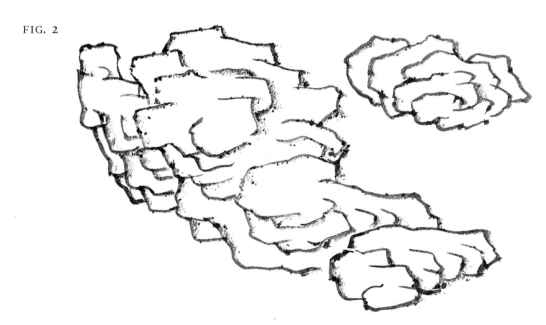

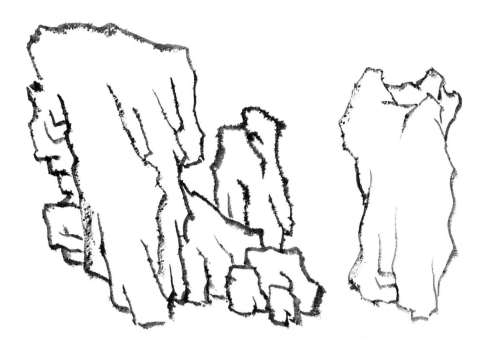

FIG. 3

When doing the contours of a large rock, there should be pauses, turnings, variations in width, and even 'breaks' in a stroke, with the brush held vertically or obliquely as required. When the brush is held obliquely, the tip usually moves towards the right when it touches the paper. To bring the brush to a vertical position, rotate the stem inward with the thumb, as already described; to return it to an oblique position, rotate the stem outward. The saying, 'There are vertical strokes in oblique ones, and oblique strokes in vertical ones', refers to these constant changes in the position of the brush. 'Breaks' in a contour line does not mean there should

FIG. 4

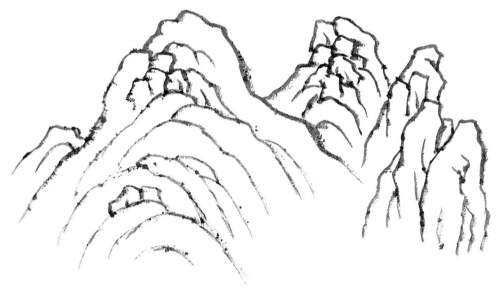

be gaps. 'Breaks' here are variations in a stroke, produced by flicking the stem with the index and third fingers. The width of a line is controlled by the pressure exerted by the brush tip on the paper: the greater the pressure, the wider the line. The brush can be moved across the paper slowly or quickly, with pauses for accentuation. When making turns, be careful not to create sharp, protruding angles.

Whether doing *gou-le* or *cun-ca*, do not load the brush with too much ink or water. Test the quality of the ink or water on a piece of waste paper first.

Over thirty kinds of rock textures can be produed with *cun* strokes, as illustrated in FIGS 5–35. Some of these are merely variations of others.

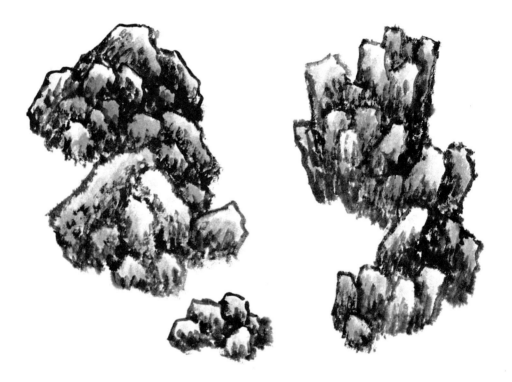

FIG. 5 Alum-lump texture: often seen in Chinese paintings. The usual method is to draw the contours of a rock first, breaking it into several surfaces, then add the texture. The brush can be applied to the paper with some force. Texture at the base of the rock should be more solid, to indicate light and shade. If no colour is added, a thin ink wash can be applied to the base when the *cun-ca* strokes have dried. If the light/shade contrast is too marked, spread ink washes over the lighter parts of the surface – a method that can also be used for the other textures described below.

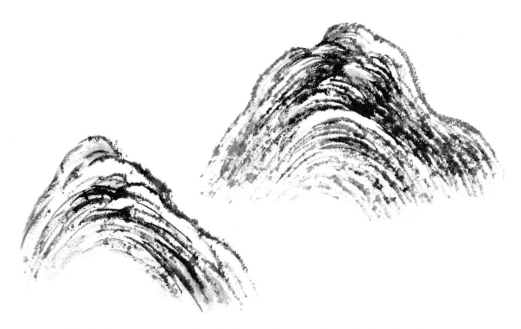

FIG. 6 Split-hemp texture: looks best when used with the alum-lump texture (FIG. 5). It consists of lines of varying length and width which should be neither too dark nor too light, neither too distinct nor too blurry. Both oblique and vertical brushstrokes should be used. *Ca* strokes are necessary and important. Of all the rock textures of the traditional Southern school, this is the hardest to master.

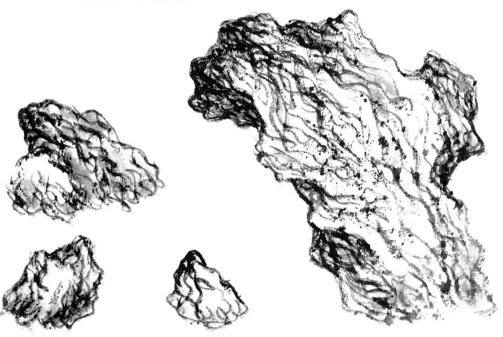

FIG. 7 Unravelled-rope texture: consists only of curves and wavy lines, which should vary in width and density. The texture lines may be drawn first. Contour lines may then be added to indicate the form of the object.

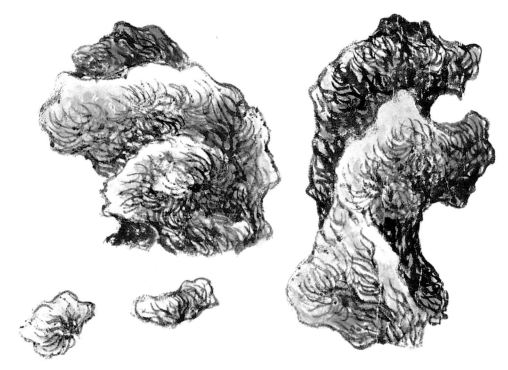

FIG. 8 Ox-hair texture: consists of short curves; sometimes appears within an unravelled-rope texture (FIG. 7), rarely on its own.

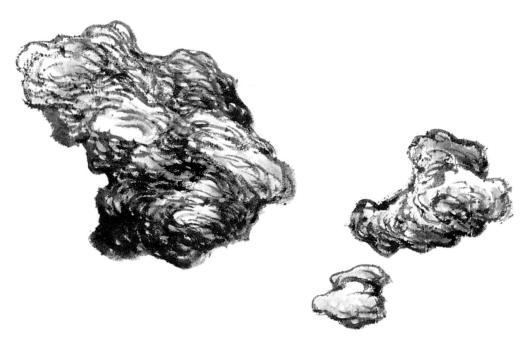

FIG. 9 Curling-cloud texture: often seen in Song dynasty paintings. This consists of short curves facing each other, resembling clouds. Sometimes part of the surface is textured before the contours are drawn. The lines can be darkened gradually by tracing over them.

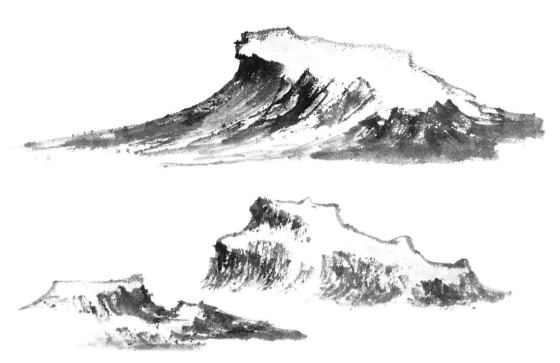

FIG. 10 Rolling-wave texture: often seen in Song paintings, it is the best texture for slopes, mesas, and overhanging cliffs of earth and stone.

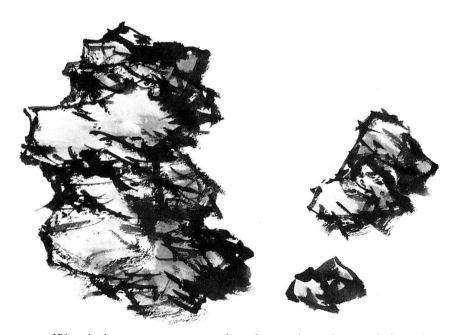

FIG. 11 Woodpile texture: executed with rapid strokes to left and right, constantly changing the position of the brush from vertical to oblique and back, and using both the side and the root of the tuft. *Cun-ca* and *gou-le* strokes are executed alternately, but sometimes the former can do the work of the latter.

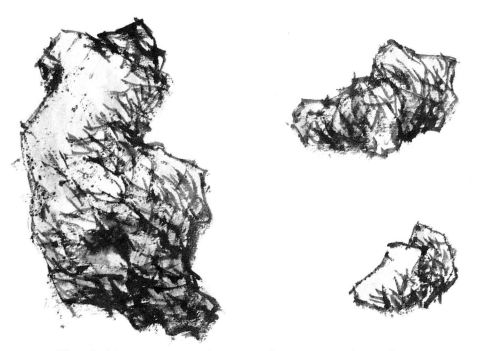

FIG. 12 Tangled-hemp texture: the texture lines are similar to those in FIG. 11 but are thinner, shorter and less rigid. *Cun-ca* strokes cannot do the work of *gou-le* in this case.

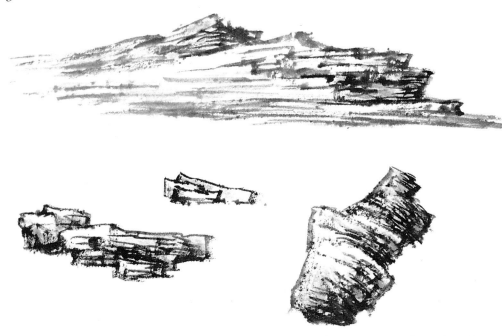

FIG. 13 Broken-ribbon texture: this is very easy to do, consisting largely of straight lines each with a bend of about 90° at one end. Hold the brush at an angle of about 30° to the paper, with all four fingers on the stem, moving the wrist for short lines, the elbow for long ones. There is no distinction between contour and texture lines.

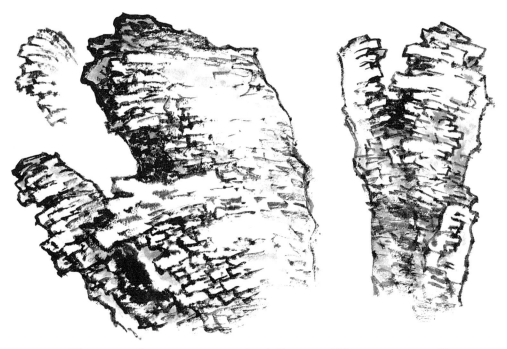

FIG. 14 Horse-tooth texture: seen in both Song and Yuan paintings. Consists of rows of small pieces that resemble stones. It cannot be used by itself in a painting; for the best results, it should be used together with some other texture.

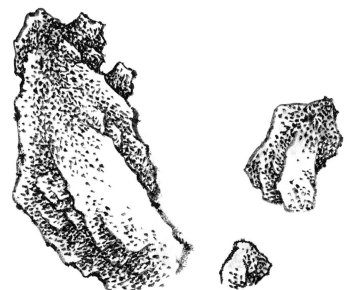

FIG. 15 Sesame-seed texture: derived from methods of texturing used by artists of the Song dynasty. Do the contours of the rock first, dividing it into several surfaces. Then thickly cover the parts that are supposed to be in the shade with dots resembling sesame seeds, which may be thinned out over adjacent surfaces. To enhance the light/shade contrast, some parts of the rock may be coated with thin ink washes.

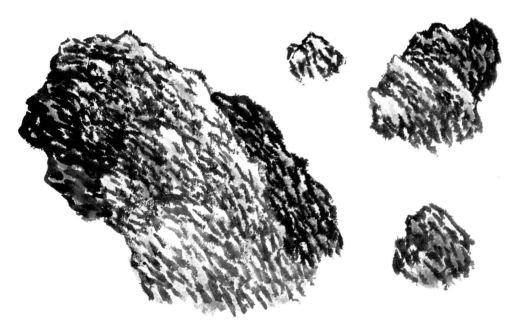

FIG. 16 Raindrop texture, also called rain-and-snow texture. Sketch out the contours of the rock roughly. Then, with the brush approximately vertical, do the texture in short, thick lines, starting from crevices in the rock and gradually spreading the lines over the whole surface. Note the effects of light and shade. Do not spread the lines evenly, nor do too much rubbing (*ca* strokes).

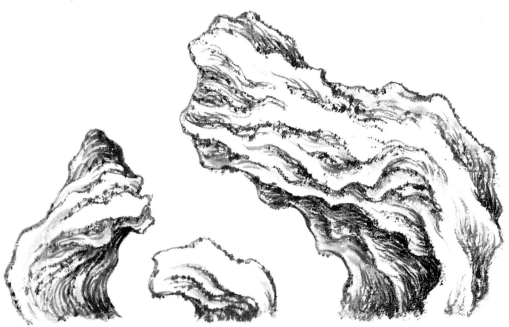

FIG. 17 Ghost-skin texture: do the contours first. Then divide the surface into layers with texture lines, giving it a wrinkled appearance, and add just a few *ca* strokes. The texture lines should be firm but not rigid, and should be executed with the brush held obliquely.

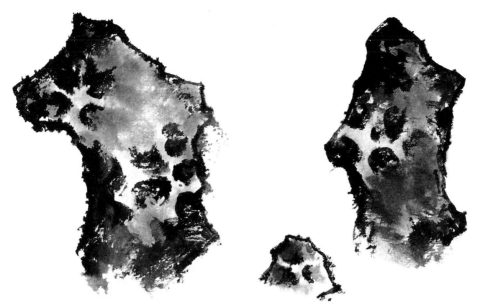

FIG. 18 Skull-like texture: often seen in paintings of hills and rocks of the Northern Song and also in paintings of rock gardens. It consists of counterpoised semicircles that resemble skulls. These must be made to look natural so as not to cause fear or disgust! The texture should be coated with thick or thin ink washes. This texture should be used together with the chopper-cut (FIG. 25) or axe-cut texture (FIG. 26), not by itself.

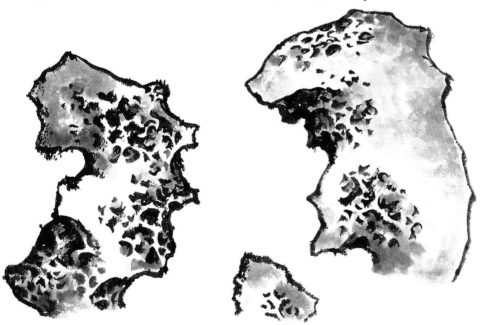

FIG. 19 Ghost-face texture: somewhat similar to the skull-like texture, to which some light tapping strokes are added. There is no need for any *ca* strokes. Veins in the rock should show up slightly in a few places. Add thin ink washes to enhance the three-dimensional effect of the painting.

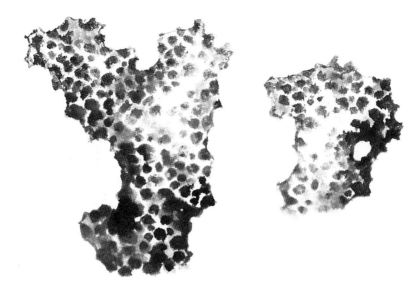

FIG. 20 Bullet-hole texture: resembles raindrops falling on the surface of a pond. It is made up of large and small round dots, painted in different shades of ink and distributed with varying density over the surface. Contours should be sketched in lightly. No *ca* strokes are needed. When the texture has been completed, coat it with thin ink washes, lightly showing the veins of the rock. Rockeries were often painted with this texture in the Song dynasty.

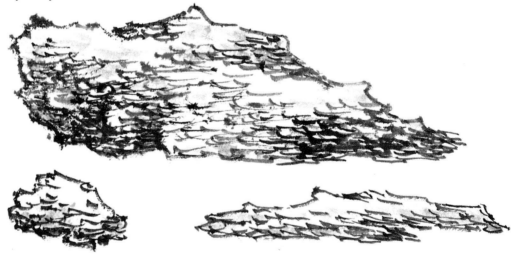

FIG. 21 Finger-flicking texture: use a brush with a long stem. Hold the top of the stem between the thumb and the index and middle fingers, or just between the thumb and index finger. It should be held loosely so that the brush appears to be dangling above the paper. All strokes are made with the brush in this vertical position and flicked towards the right. Do the texture lines first, then the contours. The power of each stroke comes from the painter's concentration rather than his fingers. A beginner could use a slightly bald brush, because one with a pointed tip slips.

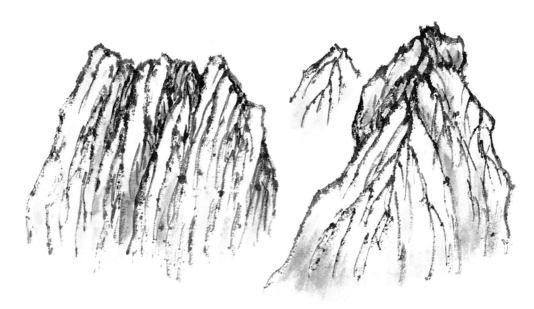

FIG. 22 Lotus-leaf texture: do one or two principal clefts in the rock or mountain first. These should be painted with a brush held vertically and should extend downward from the top of the rock or hill. Then do a number of smaller clefts branching out from the principal one like the veins of a leaf, but be careful not to produce a regular geometric design. *Ca* strokes added with an obliquely-held brush will enhance the realistic effects of the painting.

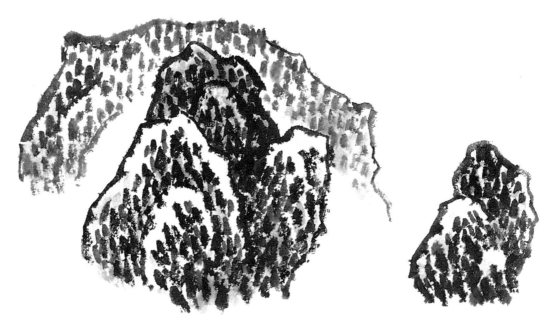

FIG. 23 Bean-pod texture: similar to the raindrop texture (FIG. 16), except that the dots are a little larger and are spread more evenly over the surface. They are executed with tapping strokes. Sometimes they are painted densely over the surface of a rock or hill.

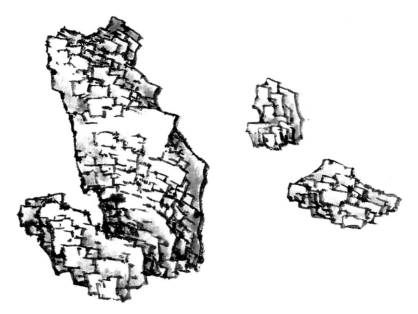

FIG. 24 Cracked-jade texture: executed with *gou-le* instead of *cun* strokes, it consists of contours, not texture lines, an unusual feature. *Ca* strokes are rarely used. The texture has the appearance of a number of large and small squares or rectangles piled together. Light and shade are produced by varying the density of the squares.

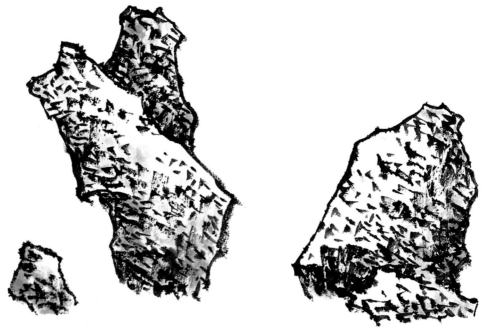

FIG. 25 Chopper-cut texture: the lines resemble grooves made by a chisel, except that the 'chiselling' is done by the tip and side of the brush. The contours of the rock should be delineated first. Putting some angles in the texture lines of the darker parts of the rock enhances the artistic effect.

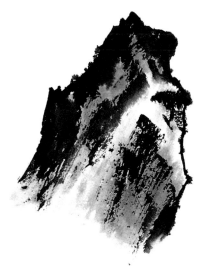
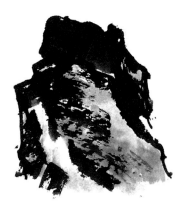

FIG. 26 Big axe-cut texture. Either the contours or the texture can be executed first; the two can also be executed simultaneously. Use the tip and side of the brush alternately. Sometimes, such as when doing the contour lines on the left, the brush can be held at an angle of 30° to the paper, with all four fingers at the middle of the stem. With such a grip, the tip of the tuft moves along and delineates the outer edge of a line while the side delineates the inner edge. Lines drawn in this way can vary in width with no breaks in them, and they will be smooth along the outer edge and downy along the inner edge. When the lines are in place, 'axe out' crevices in the rock with a large wolf brush. Every stroke must produce the desired effect; there must be no retracing or superfluous strokes. This means that the 'axe' strokes must be executed with care as well as vigour. Avoid rashness and crudeness.

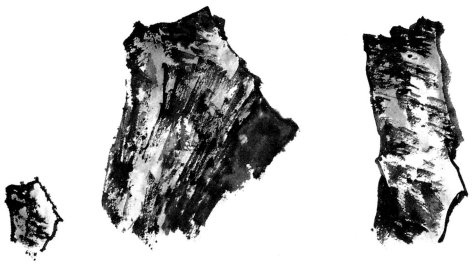

FIG. 27 Small axe-cut texture: executed in the same way as the large axe-cut texture, except that the strokes are smaller. It can appear together with the chopper-cut texture (FIG. 25).

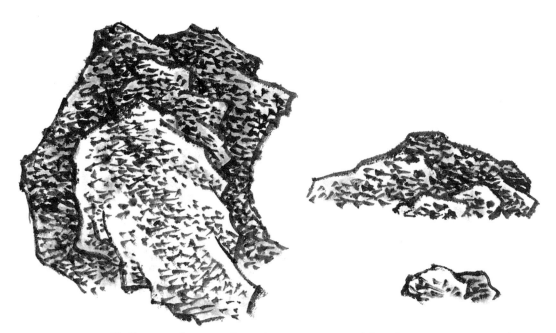

FIG. 28 Pulling-nails-out-of-mud texture, or nail-head texture: executed in the same way as the sesame-seed texture (FIG. 15), lines being replaced by dots. The marks on the rock surface resemble those left by nails picked up from mud, being thick at one end and pointed at the other. Light/shade effects are produced by varying the concentration of marks.

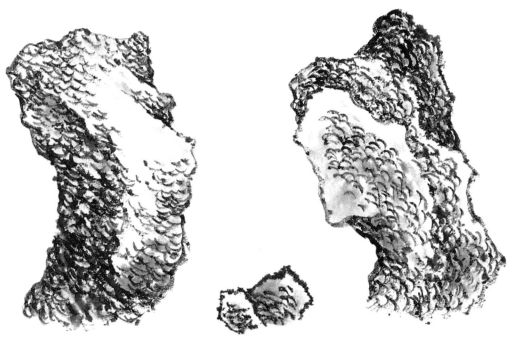

FIG. 29 Fish-scale texture: contour lines are drawn first. The texture consists of small curves facing up, down, or both ways.

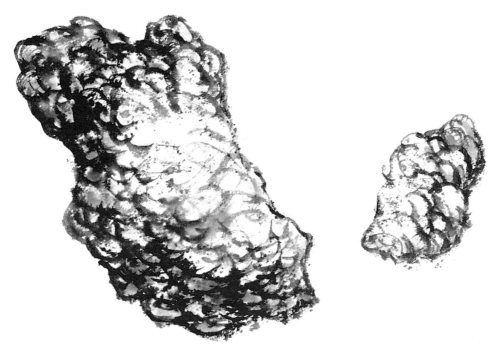

FIG. 30 Dragon-scale texture: similar to the fish-scale texture (FIG. 29), except that the marks and lines are larger. The texture can be drawn before the contours, and the curves (scales) can face any direction. Light and shade, front and rear, are revealed by the shape and density of the scales.

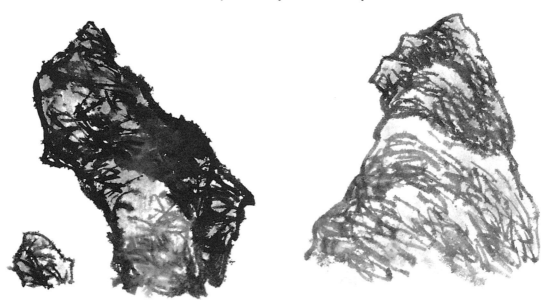

FIG. 31 Bedraggled texture: the contour lines should be drawn first. Use a brush loaded with ink and do all the strokes with the brush held vertically. Move it rapidly up and down, to left and right, completing the whole texture in one go. When the lines have dried, go over them with different shades of ink washes to show light and shadow.

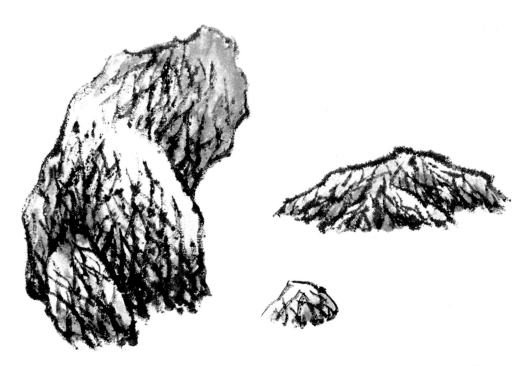

FIG. 32 Torn-net texture: a variation of the unravelled-rope texture (FIG. 7), but the contour lines should be drawn first. The texture consists of intersecting lines.

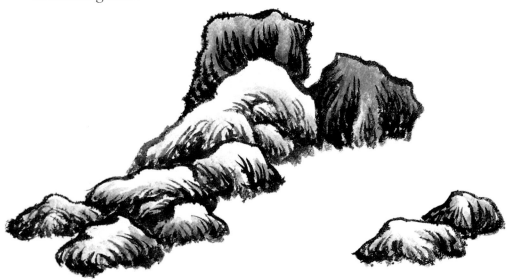

FIG. 33 Water-weed texture: said to be a variation of the alum-lump texture (FIG. 5). Every stroke must be clear and distinct. The base of the rock should be solid, with no gaps in the line, and the whole texture should possess a decorative quality like a woodcut. It should be coated with different shades of ink washes to increase the light/shade contrast.

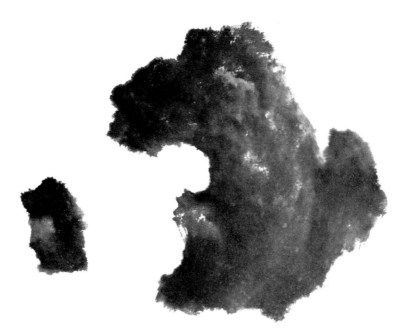

FIG. 34 Boneless texture: ink or colour washes replace the usual texture lines. No contours. Thick ink or colour is used for the darker parts of the rock, and thin ink or colour for the lighter parts. The front and back, sunny and shaded parts of the rock can all be shown in this way. Traces of brushstrokes are only faintly visible. Colour is used more often than ink.

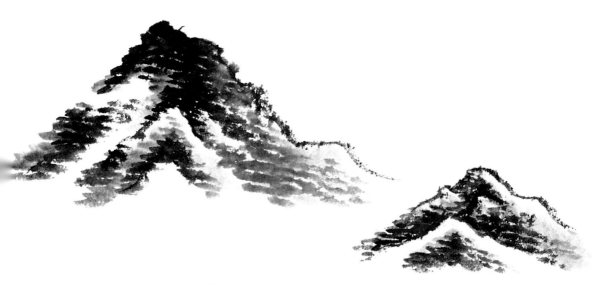

FIG. 35 Rice-dot texture: consists of layers of rice-shaped dots and just a few contour lines. Blurry parts of the texture suggest clouds and smoke and a changing atmosphere. The best texture for depicting rain scenes. Fine examples are in the paintings of Mi Fei and his son, dating from the Northern Song.

CRAGS, MESAS, SLOPES, BEACHES, EMBANKMENTS, PEAKS,
RANGES, GORGES, RIDGES

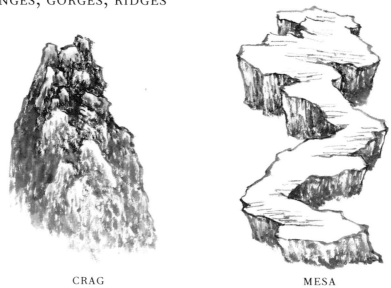

CRAG

MESA

FIG. 36 Crags are painted mainly with texture strokes. The ink should be somewhat thick at the top of the crag, but light on the sides, which are often painted with a misty look. When painting a mesa, do the outlines first, then add vertical or horizontal texture lines with the *pian feng* (side stroke). If the three-dimensional effect is not strong enough, break up the surface by putting in some horizontal lines of varying lengths, but do not use horizontal *ca* (rubbing) strokes.

EMBANKMENT

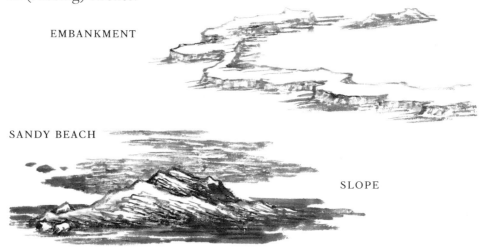

SANDY BEACH

SLOPE

FIG. 37 Slopes and banks are painted in more or less the same way as crags and mesas. When painting a sandy beach, use thin ink and a brush that is fairly dry and do the texture with horizontal *ca* (rubbing) strokes, holding

the brush obliquely. The texture may be darkened with a second coating when the first has dried. A long embankment is painted in the same way as a stone mesa but with fewer strokes.

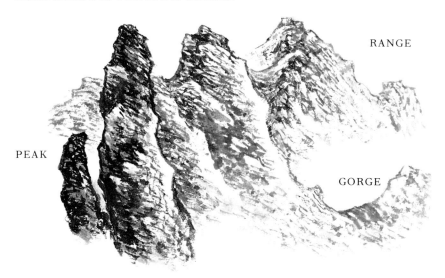

RANGE

PEAK

GORGE

FIG. 38 Peaks are painted like towering rocks of different sizes. A mountain range can be depicted with an undulating skyline and a combination of peaks and crags. When these are positioned in a circle or semicircle, 'valleys' and 'gorges' appear automatically in the picture.

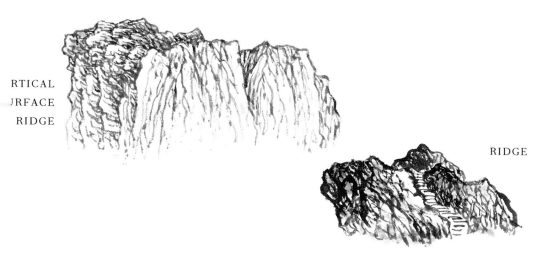

RTICAL
JRFACE
RIDGE

RIDGE

FIG. 39 The ridge in the picture on the right has the unravelled-rope texture (*see* p.29). The short horizontal lines in between are the stone steps of a narrow path. A ridge's vertical surface can best be depicted with two kinds of texture. The lotus-leaf texture (p.37) is advisable on a receding surface, as shown in the picture.

TREES

In Chinese landscape painting there are certain stylized ways of doing trees that have been practised for a long time. For example, trunks and thick branches are usually depicted like tubes, with leaves added around them but seldom concealing them completely. The saying that 'a tree must have four aspects' means that a tree and its branches must be portrayed in a way to show that they have a front and back, and a left and right side. Just as rocks are divided into surfaces, so a tree must have a front and a back. While it may be easy to show this when you are painting a withered or dormant tree, it will not be so easy if it is a tree with thick foliage, as is often the case in a Southern landscape.

Except for the level-and-distant perspective (*see* p.111), which is used to depict a view on the artist's or spectator's eye level, a traditional Chinese landscape is always composed of layers one above the other so that it is not easy to distinguish between what is near and what is far and what should be dark and what light. And if the trunks and branches of the trees are completely concealed by foliage, the appearance of the whole painting may become unclear. Painting trees in the above way, with distinct sides and trunks and branches visible, is one way of solving this problem. The paintings of the Northern school are a little different in that they have fewer layers, are simpler, and possess an obvious sense of space. In such paintings, it is easier to depict the branches of trees in different positions – left or right, in front or behind, extending upwards or downwards.

When you are painting the trunk or branches of a tree, it is best to start from the middle of the trunk or branch to make it easier to judge how much space is needed above and below.

If a line cannot be completed with one stroke and a second stroke is needed, raise the brush slightly at the end of the first stroke. This makes it easier to go on to the next one.

The trunk of a tree should be textured. After the position of the trunk has been fixed and its middle section delineated with ink, you can put in the texture, right down to the root. Use a dry brush first, to give the trunk a rugged, uneven appearance; then go over the texture with more delicate strokes.

As you apply your strokes, pay constant attention to the shape and contours of the tree and note how high it should reach. Remember, a single tree is often harder to depict than a forest.

When you are doing the lines of a tree, there must be pauses, turnings and accentuations in your brushstrokes, as well as variations in the width of the lines and the shade of ink. The *zhong feng* (centre stroke), *pian feng* (side stroke), and *lu feng* (open stroke) can all be used. Some dotted leaves have to be painted with the *ni feng* (counter stroke) (*see* p.20).

Some leaves are painted solid black. They are called dotted leaves, though the 'dots' may be of many shapes as will be explained later (*see* p.50). Other leaves are depicted in outline only. When you are painting a forest, it can be very effective to have trees with dotted leaves and outlined leaves alongside or behind each other, with a withered tree interposed here and there. Such a contrast gives more life and spirit to the painting. Some dotted leaves resemble moss, but they can never be mistaken for it. On the contrary, such a resemblance sometimes helps to unify the painting.

Trees that are short and simple in appearance will look like small trees when placed in the foreground and like large ones when in the background. The shade of ink is the only difference in the way they are painted.

The ways of painting trees and their various parts will be discussed under five general headings:

1. *Trunks, branches, roots* (FIGS 40–4)

A general rule for painting the trunk, branches and twigs of a tree is that the higher they are the thinner they should be, and, conversely, the lower the thicker. As shown in the illustrations, twigs appear only on the thinner branches or at their tips. Irrespective of whether they extend upwards or downwards, such twigs are generally shaped like a Y or an inverted V. Depending on circumstances, they can be long or short, in singles or in pairs, multiplied or omitted altogether, dense or sparse, in the foreground or the background. You can move your brush upwards or downwards when doing a line. A thin twig can be drawn in one stroke, but a thick one may need a double stroke (two parallel lines).

The textures of trees are simple to do. Since there are so many kinds of trees, it is impossible to give all their textures; suffice it to mention the most common ones. The texture of the pine resembles fish scales (*see also* p.172);

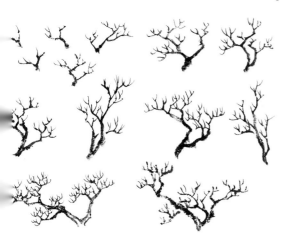

FIG. 40: Ways of painting branches (1)

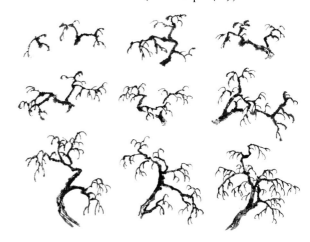

FIG. 41: Ways of painting branches (2)

that of the cypress is like twisted silk; the willow's like inverted V's; the tung tree, horizontal lines; and the Chinese toon, a texture of vertical lines. Knots should be painted on the protruding parts of a trunk and should not be spaced uniformly.

The roots of trees may or may not be shown, depending on the needs of the painting. If they are shown, they should be delineated clearly and vividly; otherwise, it is better to leave them out.

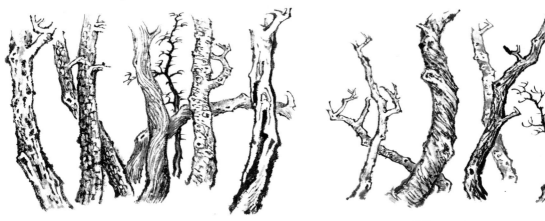

FIG. 42: Ways of painting trunks (1) FIG. 43: Ways of painting trunks (2)

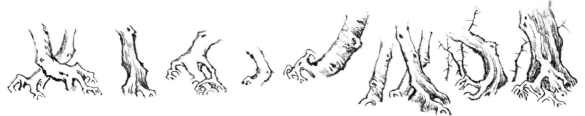

FIG. 44: Ways of painting roots

2. *Dormant trees* (FIG. 45)

There are two basic ways of depicting the branches of a dormant tree in the dead of winter. If the branches extend upwards, they are painted like antlers. If they extend downwards, they are painted like crab claws. Sometimes a few curves resembling crescent moons are added on the antlers.

The usual way of painting the drooping branches of a willow is to start each stroke with a slight upward thrust of the brush, followed by a quick downward move that must be checked at the right instant. As doing such a stroke is not easy, the Chinese have the saying: 'The hands are the hardest to portray in figure painting; the willow is the hardest in painting trees.' When you are painting a willow in spring or summer, a few touches of green on the branches will suffice; it is not always necessary to add leaves. The so-called snowflake pattern is a variation of the antler and crab-claw patterns.

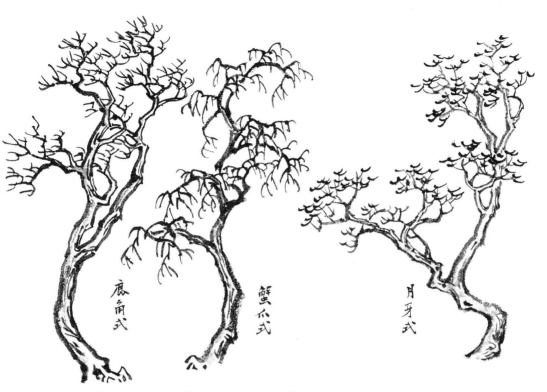

FIG. 45 (left to right): Branches shaped like antlers, crab claws and crescent moons.

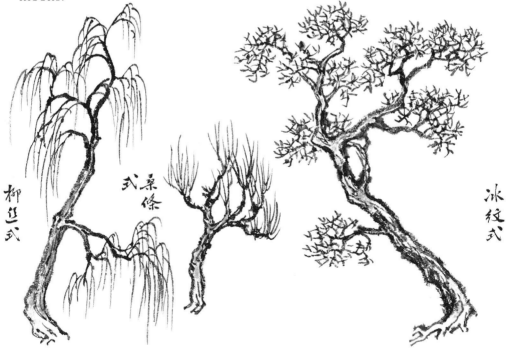

FIG. 46 (left to right): Willow branches, mulberry branches, snowflake pattern.

3. *Trees with dotted leaves*

When you paint a tree with dotted leaves, you can do the trunk and branches first, then add the leaves. Be sure that there are differences in the shade, density, thickness and wetness (or dryness) of your dots; and in their positions (high, low, front, back) on the tree. Pay special attention to the position of the tree and its top. The requirements are basically the same for trees with outlined leaves.

The leaves at the tip of a branch should be darker than the others to show that they are nearer to the viewer. When you are drawing a main branch, start your lines from slightly inside the trunk, like this: |华; or from above and below the joint, like this:| 卡. It will enhance the three-dimensional effect. Dotted leaves should overlap at a number of places on the tree to create an impression of denseness, except when they are depicted with thin lines like the character '介' (*see* p.54).

Some leaves are painted like blobs, for example the large leaves of the Chinese parasol. Care should be taken to produce a harmonious appearance, not an incongruous mass of blobs. You can trace out the leaves' veins with gluey ink, but they must be very simple lines. Loose, scattered blobs should be painted with the *ni feng* (counter stroke), and each stroke should be forceful and quick. Round leaves and flat leaves can be painted with a slightly bald brush. If your brush is new, use the *cang feng* (concealed stroke).

Painting bamboo is difficult. Some bamboo leaves hang down; others grow upwards (bamboos with such leaves are called 'sky-facing bamboos' and are the hardest to portray). One, two, or more branches can grow from a single joint. The joints in the lower part of a bamboo stem (culm) are more closely spaced than those at the top, and the stem itself becomes thinner the higher it goes. Some artists draw the stem first and then add the leaves, which is the usual way when doing a flower painting. But if you are doing a landscape, put in the leaves first and then join them with stems. Make the leaves denser if there is a hill or boulder behind the bamboo, but do not use too many shades of ink as it will only produce a mottled appearance. (*See also* p.168.)

Many varieties of pine have been portrayed in Chinese paintings: the masson pine, golden larch, needle-leaf pine, etc. Most pine branches extend horizontally.

A poplar looks good with leaves shaped like flattened V's (⌣). They are lively and unconventional.

There are about thirty varieties of dotted leaves as shown in FIGS 47–59.

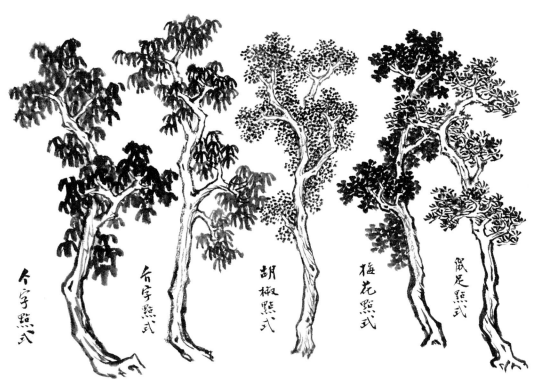

FIG. 47 (left to right): 个-shaped leaves, 介-shaped leaves, pepper-dot leaves, plum-blossom leaves, mouse-track leaves.

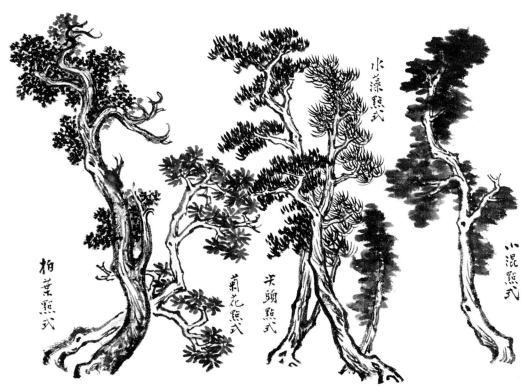

FIG. 48 (left to right): Cypress leaves, chrysanthemum leaves, pointed leaves, algal-type leaves (1), small blob leaves.

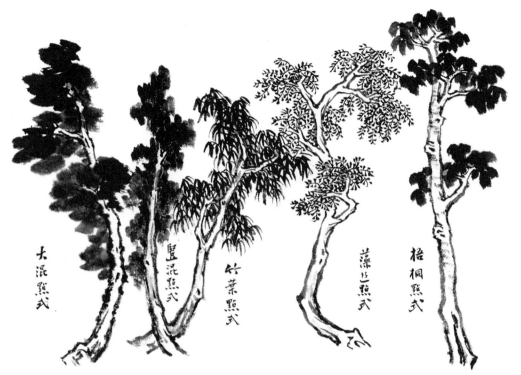

FIG. 49 (left to right): Large blob leaves, vertical blob leaves, bamboo leaves, algal-type leaves (2), Chinese parasol leaves.

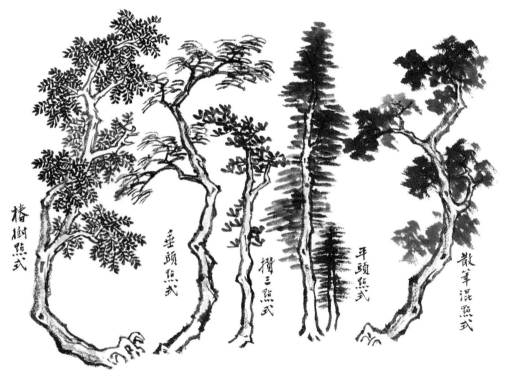

FIG. 50 (left to right): Toon and elm leaves, hanging-head leaves, trifoliate leaves, level-top leaves, scattered blob leaves.

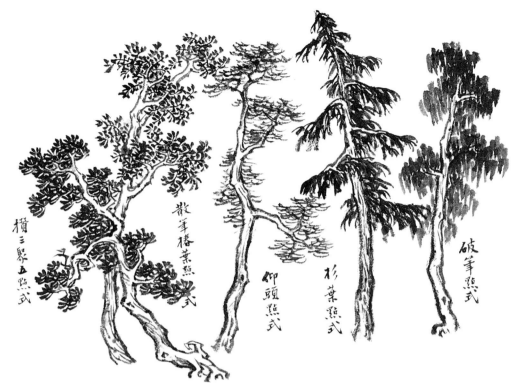

FIG. 51 (left to right): Trifoliate and quinquefoliate leaves, scattered toon leaves, raised-head leaves, cedar leaves, split-brush leaves.

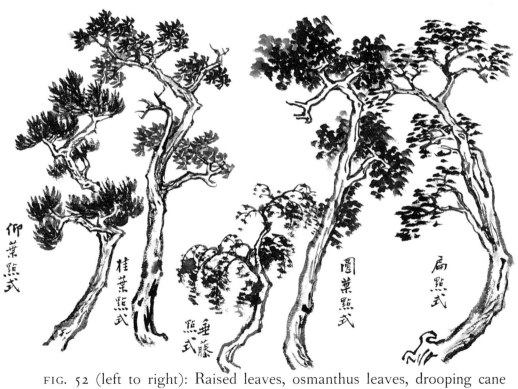

FIG. 52 (left to right): Raised leaves, osmanthus leaves, drooping cane leaves, round leaves, flat leaves.

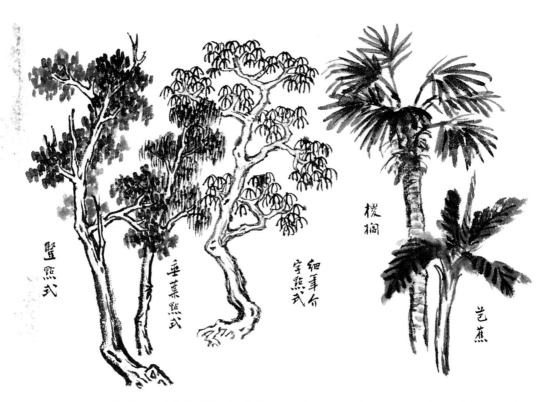

FIG. 53 (left to right): Vertical leaves, hanging leaves, 介-shaped leaves in thin lines, palm leaves, banana leaves.

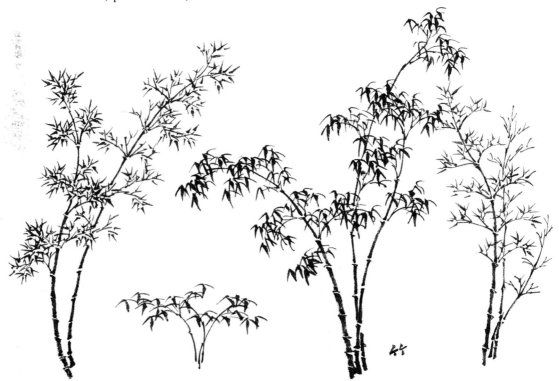

FIG. 54: Bamboos.

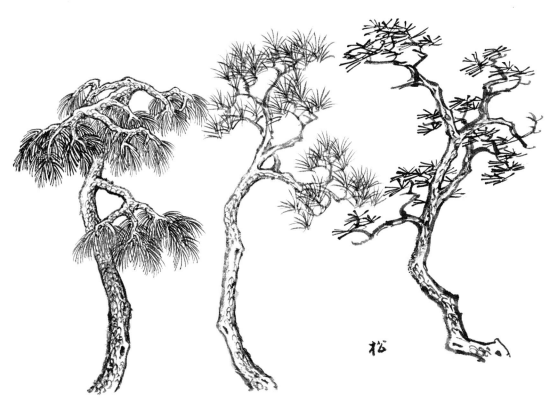

FIG. 55: Pines.

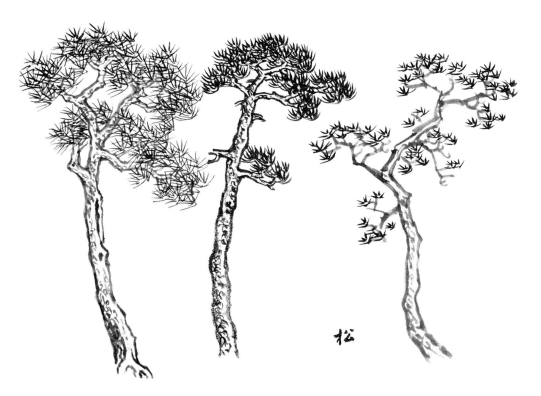

FIG. 56: Pines.

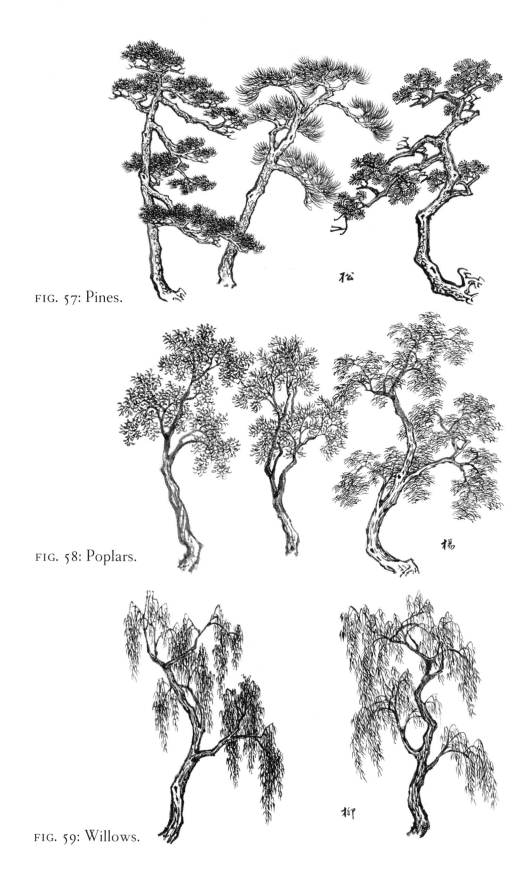

FIG. 57: Pines.

FIG. 58: Poplars.

FIG. 59: Willows.

56

4. *Trees with outlined leaves*

Leaves delineated in outline should be coloured. Sometimes they are not, as is often the case in ink landscapes. When doing leaves in outline, pause for accentuation at the beginning of each stroke to increase the vigour of the stroke and to allow for possible variations.

There are about forty varieties of outlined leaves (*see* FIGS 60–70).

The first and second types of maple leaves are best for a small painting or distant trees. The third type of maple leaves, star-shaped with double outlines, looks best in a large painting.

At the beginning you may find it hard to make leaves look round and vivid. If so, do not try to draw each leaf in one stroke. Draw two half-circles, one above, the other below, joined at both ends.

Pine leaves may be shaped like isosceles triangles, each done with two strokes. Such leaves are highly ornamental and can also be used on other trees.

Type (1) bamboo leaves possess a quaint, antique charm.

Cherry-shaped leaves are not the same as round leaves. They are smaller and of different sizes. They also differ from fish-egg leaves.

When painting the trunk or thick branches of a willow with outlined leaves, be sure to leave enough room for putting in the leaves and joining them to the branches.

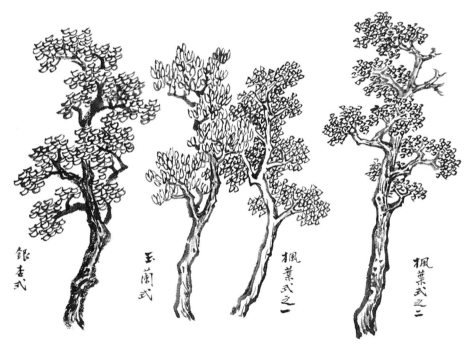

FIG. 60 (left to right): Gingko leaves, magnolia leaves, maple leaves type (1) and type (2).

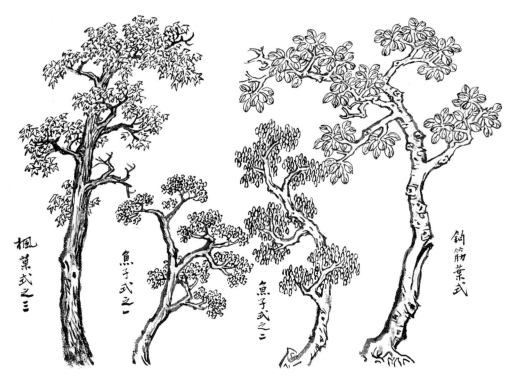

FIG. 61 (left to right): Maple leaves type (3), fish-egg leaves type (1) and type (2), leaves with veins.

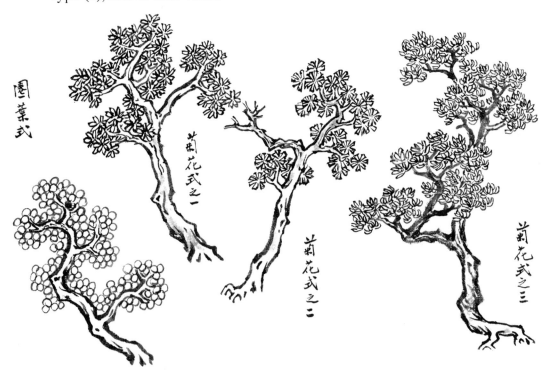

FIG. 62 (left to right): Round leaves, chrysanthemum-shaped leaves type (1), type (2), and type (3).

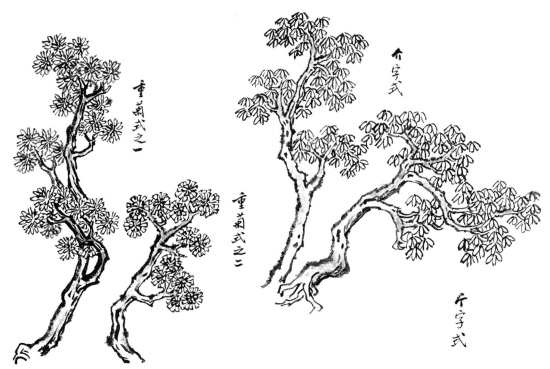

FIG. 63 (left to right): Double or multiple chrysanthemum-shaped leaves type (1) and type (2), 介-shaped leaves, 个-shaped leaves.

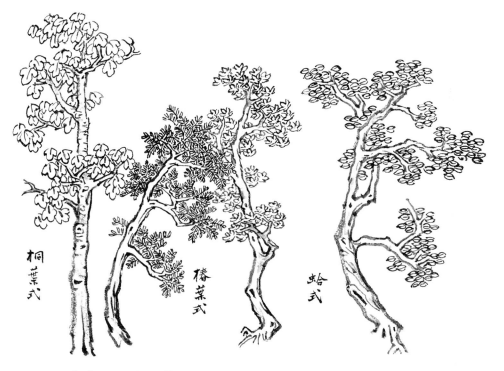

FIG. 64 (left to right): Chinese parasol leaves, toon leaves, plum-blossom leaves, clam-shaped leaves.

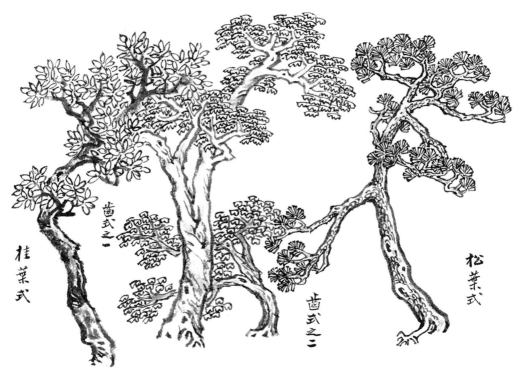

FIG. 65 (left to right): Osmanthus leaves, tooth-shaped leaves type (1) and type (2), pine leaves.

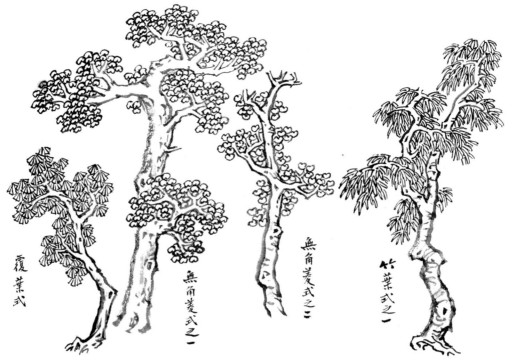

FIG. 66 (left to right): Overlapping leaves, angleless water-chestnut leaves type (1) and type (2), bamboo leaves type (1).

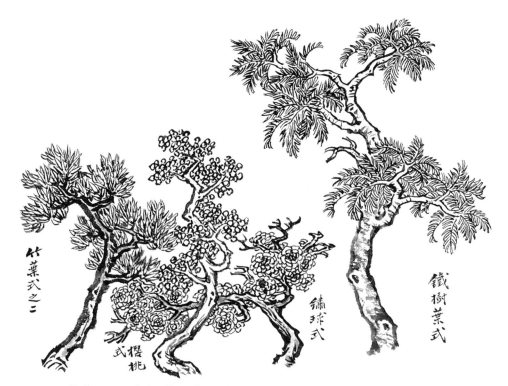

FIG. 67 (left to right): Bamboo leaves type (2), cherry-shaped leaves, hydrangea-shaped leaves, sago cycas leaves.

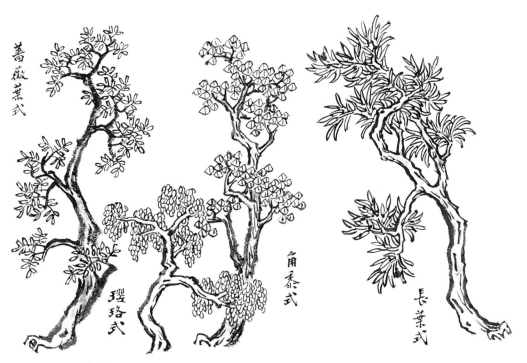

FIG. 68 (left to right): Rose leaves, rosary-like leaves, angular millet leaves, long leaves.

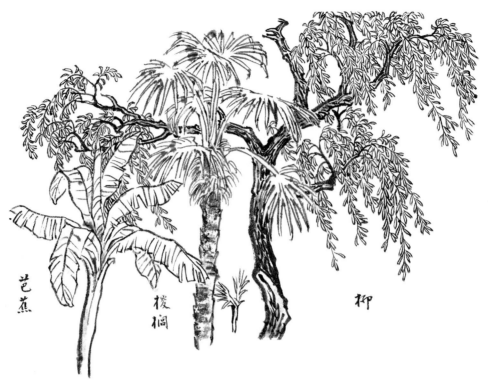

FIG. 69 (left to right): Banana leaves, palm leaves, willow leaves.

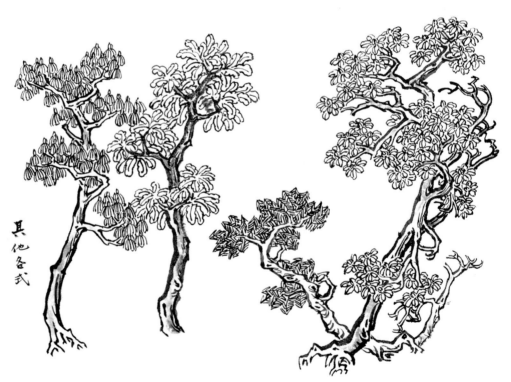

FIG. 70: Other kinds of outlined leaves (bodhi tree second from left).

5. *Groves*

Eight ways of painting trees in groups are shown in FIGS 71–6.

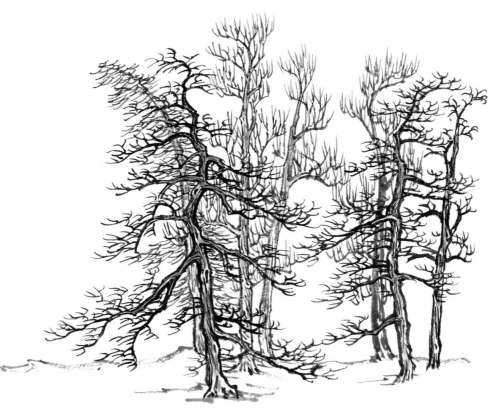

FIG. 71

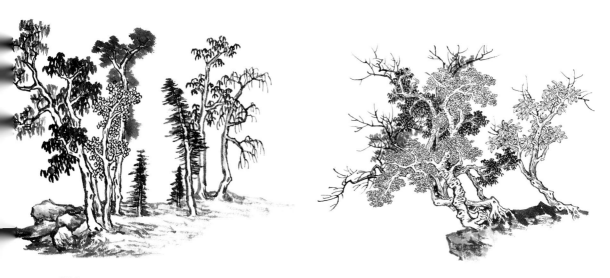

FIG. 72 FIG. 73

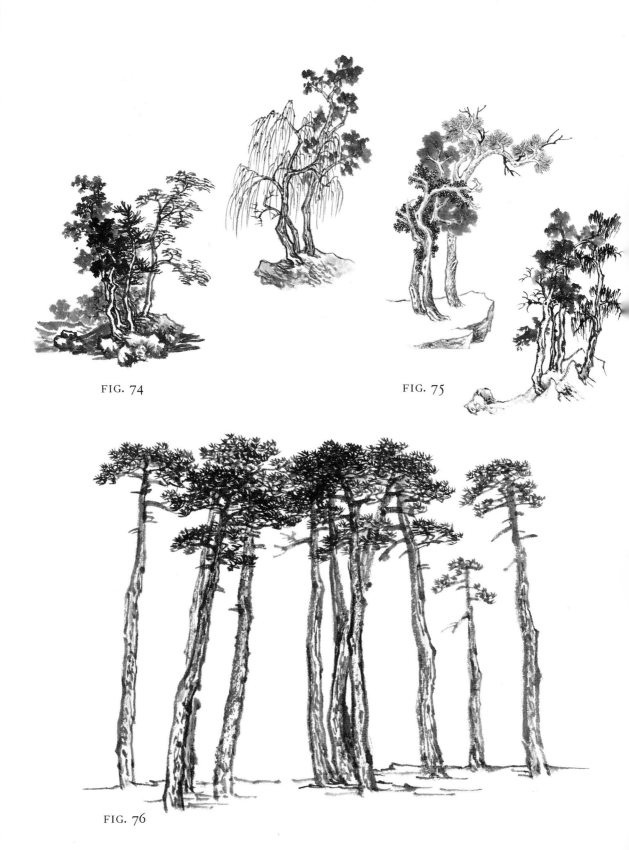

FIG. 74

FIG. 75

FIG. 76

Moss

Trees, rocks and moss are important components of a Chinese landscape painting. There are many kinds of moss and your choice should be made according to the textures of the hills and rocks and the composition and style of the painting. Some kinds of moss can also be used to represent dotted leaves.

Moss dots, like dotted leaves, can be painted in many different shapes. FIGS 77–80 show the kinds of moss often seen in landscape paintings (*see* p.97 for FIG. 80). They are classified according to their shapes.

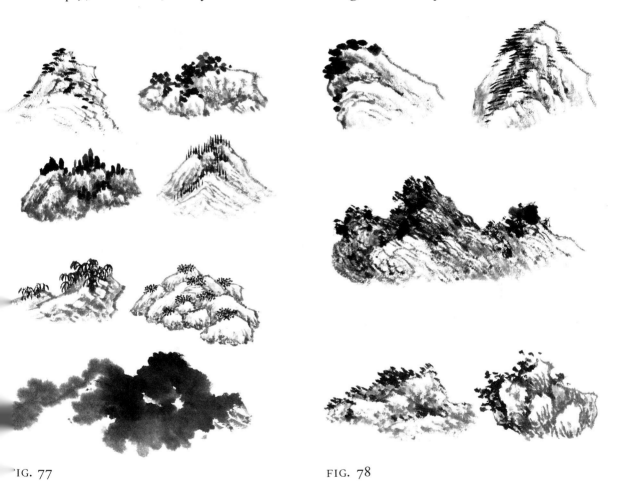

IG. 77

FIG. 78

FIG. 77: Flat moss (top left), round moss (top right), vertical moss (second row left), pointed moss (second row right), 个-shaped moss (third row left), pepper-dot moss (third row right), big amorphous moss (bottom).

FIG. 78: Small amorphous moss (top left), thin flat moss (top right), scattered moss painted with the *zhong feng* (centre), slanting moss (bottom left), flying (or detached) moss (bottom right).

FIG. 79: ↑-shaped moss (top left), cypress-leaf moss (top right), plum-blossom moss (bottom left), mixture of slanting and pointed moss (bottom right).

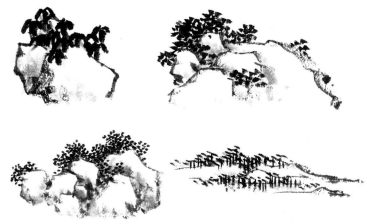

There are two ways of painting a landscape with flat moss dots:

1. Paint the trees first. Then do the contours and textures of the hills and rocks with thin ink. Add the flat moss dots, also with thin ink, starting with the rock crevices. When all the moss dots have been done, add more dots and textures where necessary, for example on the darker parts of the rocks, using thick ink. Lastly, put some dots in gluey ink on the rocks in the foreground. A painting done in this way possesses both depth and solidity, though the textures are often overshadowed by the moss.

2. Paint the trees first, followed by the hills, rocks, and their textures. Add flat dots in thick and thin ink in the darker parts of the landscape (including the base and surface of rocks). Hold your brush one or two inches above the paper at the start. Bring it down and complete the painting in one go, then add a few large dots in gluey ink as finishing touches.

Round moss, upright moss and pointed moss should be painted with thick and thin ink alternately. Vertical dots should be made with a stump brush, preferably an old one. Pointed moss can be painted with a new brush.

↑-shaped moss and pepper-dot moss should also be done with thick and thin ink alternately. More dots should be added on the upper part of a rock surface. Large blobs are sometimes called Mi dots because Mi Fei and his son, Mi Youren (Mi Yo-jen), of the Northern Song dynasty painted moss this way in rain scenes. It is better to use thick and thin ink alternately, but sometimes dots or blobs in thin ink can be put in first and those in thick ink added later (*see* FIG. 77).

Small amorphous moss, flat moss in thin lines, and scattered moss painted with the *zhong feng* should all be done with thick and thin ink

alternately. Painting scattered moss dots (sometimes called 'thirsty moss' because it is done with a dry brush) was an invention of Wang Meng (?–1385, Yuan artist). This is how it is done: paint the trees, rocks and ornamental objects of a landscape first. When all these are in place, note carefully where the moss dots should appear – on the surface or base of the rocks, on the trees, branches, houses, or figures. Then, having dipped your brush in thick or gluey ink (rarely in heavy or thin ink), hold it vertically above the chosen spot and bring it down with some force so that your wrist strikes the table with a thud and the hairs at the tip of the brush are parted by the impact. Most of the resulting moss dots will be large. You can add small dots as finishing touches. Beginners may be reluctant to use this method, but its subtleties can be learnt with practice.

Oblique or slanting moss should also be painted at one go, but it should not appear in every part of a painting. It can be interspersed with the flat moss. Flying moss can be painted as round, flat, or scattered dots. Although physically detached from the rock surface, the dots should appear to be part of it, which is why they are so hard to depict properly. Flying moss should not be all over a painting. It should be added only here and there as finishing touches (*see* FIG. 78).

↑-shaped moss, plum-blossom moss and cypress-leaf moss should all be painted at one go. Mixtures of oblique and pointed mosses should be done in the same way, painting the pointed dots first and then the oblique ones (FIG. 79).

The so-called inlaid-gem moss is often included in a blue-green landscape. If blue-green appears too dull by itself, add large dots with gluey ink where necessary. Each dot must be clear and distinct. When they have dried, coat them with mineral green, which will give them an unusual appearance. Cinnabar dots can also be added on a blue-green landscape to heighten its brilliance. Another, traditional, way is to dot the rock surfaces with vermilion.

Mineral-green moss is often used in rain scenes. Care must be taken over where to add the dots and in what quantities. A general rule is that they must not be distributed uniformly (*see* FIG. 80).

Moss dots serve four purposes:

1. Where the texture has not been painted well, they can cover up the defects.
2. They enhance the effects of colours.
3. They help to liven up a painting that is otherwise dull or unclear.
4. They increase the downy appearance of small trees, shrubs, grass and rocks in a landscape painting. Without moss dots, the trees, rocks, etc. may look spotlessly clean and very unnatural. There are, however, some landscape paintings without a single moss dot.

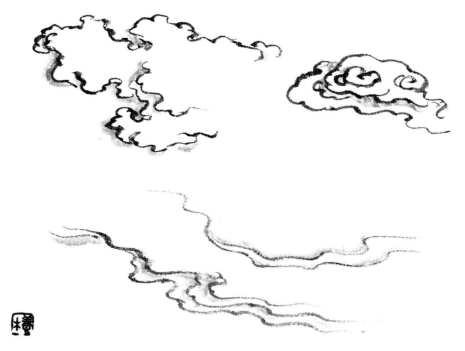

FIG. 81

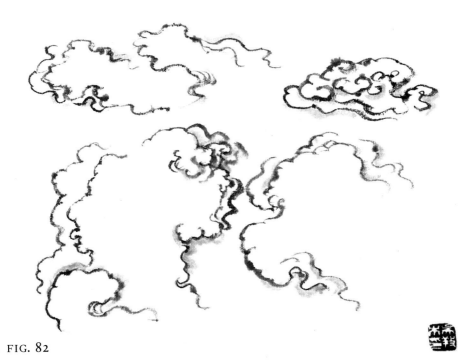

FIG. 82

Clouds are very common in paintings of hills and mountains. There are two ways of depicting them: 1. leave empty spaces of various sizes among the hills and woods, then apply thin ink washes on them, gradually blurring the outlines of the hills and woods bordering the empty spaces. 2. trace out the contours of clouds, spacing them among the hills (*see* FIGS 81–3). The lower examples in FIG. 82 are of clouds in summer. The lower example in FIG. 83 represents a sea of clouds.

A landscape painting must contain empty spaces as well as concrete objects. Clouds, as well as sky and flowing water, are an important part of the spaces. If concrete objects are depicted everywhere, or if there is not enough empty space, the painting will appear overloaded. The concrete is accentuated by space, so due attention must be paid to depicting the latter.

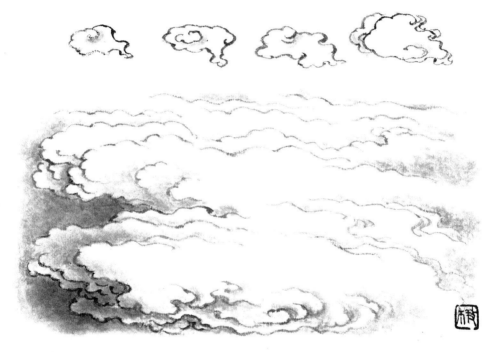

FIG. 83

An expanse of water is usually represented by a blank space. Just a few lines in thin ink are sometimes added to create the effect of waves or ripples (FIG. 84). The upper drawing in FIG. 85 is a representation of big waves; the lower one is of ripples, in which the thin lines were put in first and the thick lines added later. This combination of thick and thin lines was a method used by artists of the Yuan dynasty. In FIG. 86, the upper painting is of seething spray. When painting spray, be careful not to produce too many sharp angles. The lower painting is of eddies. Take care that these do not resemble wood grain.

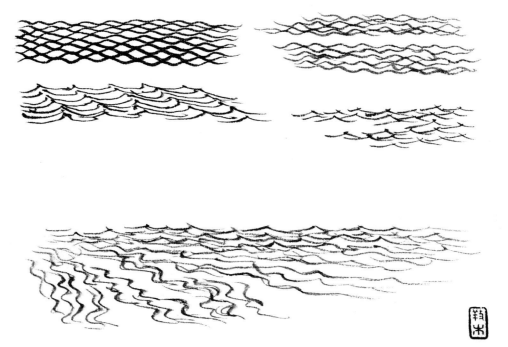

FIG. 84

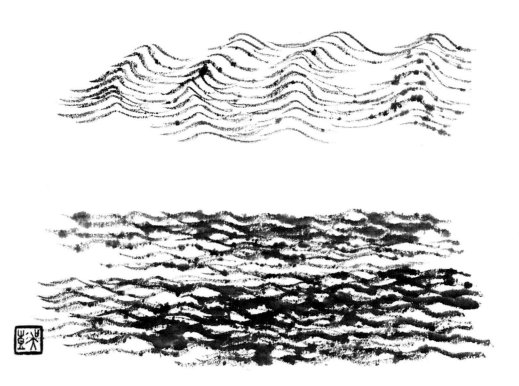

FIG. 85

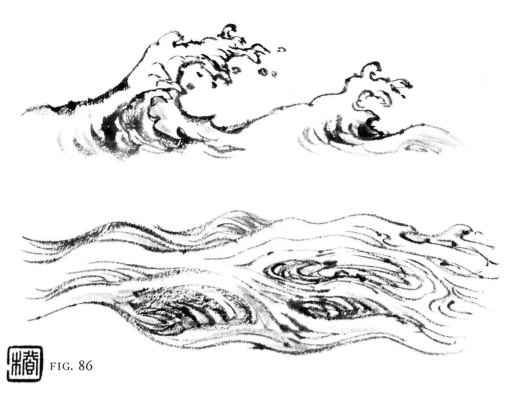

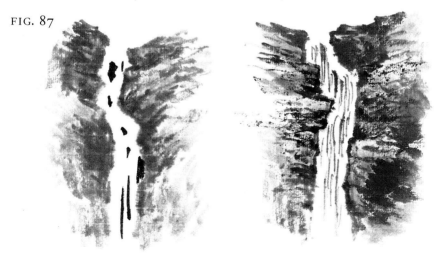

FIG. 86

FIGS 87–9 show how waterfalls are portrayed. If it is a big waterfall, the point where it starts should also be big. The rocks along the two sides of a waterfall should be in darker ink so as to show up the translucency of the water. When you are painting a distant waterfall, it is only necessary to paint two steep walls of rock with a narrow blank space between them. Including a fall of water in a painting of woods and hills will produce a sense of motion in a scene that is otherwise completely still. There are different ways of depicting the motion of the water as it falls, some examples of which are shown in FIG. 90. When you paint a waterfall in the mountains, it is best to include the foot of the fall, otherwise your painting may appear incomplete.

FIG. 87

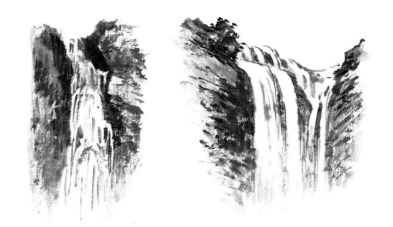

FIG. 88

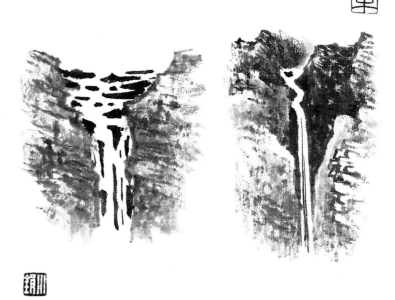

FIG. 89

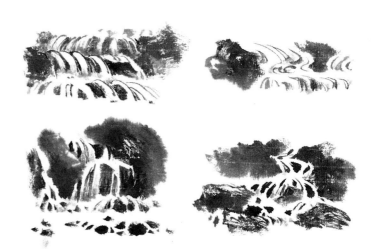

FIG. 90

How to paint smoke and mist with ink washes

Prepare a solution of light ink in a basin. Better to have too much than too little to hand. Use a large brush made of goat hair or blended hair. Be bold as well as careful, using rapid strokes. When the seepage is too great, dry it with a piece of waste *xuan* paper, then remove the superfluous parts with a clean brush dipped in clear water.

Thin clouds in the mountains are painted to resemble smoke (*see* FIG. 91). Because they are light and floating, they should not be contoured but depicted using thin ink washes. Do this by applying thin or light ink washes to parts of the paper. No trace of the brushstrokes should be visible. To create a dusk or twilight scene spread the washes over the whole paper. Dense clouds, which need no contours, can be executed by adding a small amount of heavy ink to the washes; a technique also used to produce thick smoke. Never use overnight ink for such paintings, nor add more washes after the first washes have dried.

FIG. 91

FIG. 92

Mist (FIG. 92) can be present in any season. To create this effect, spread ink washes over the paper, but leave wide, parallel blank spaces above the woods. These spaces represent mist, which should not have an undulating appearance.

DISTANT HILLS

Landscape paintings often feature hills in the distance. These are usually painted in ink (or indigo or umber if it is a painting in colour) and with just a few strokes. The nearer the darker, the farther the lighter is the general rule as shown in FIG. 93, but at sunset or twilight what is farther away may seem darker than what is nearer (FIG. 94). In Chinese painting it is not necessary to use different shades to show different degrees of illumination. Using a contrast of black and white, as when painting rocks, produces much the same effect.

FIG. 93

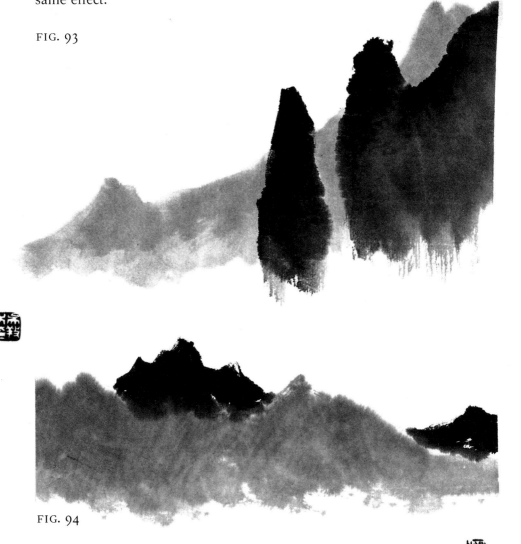

FIG. 94

FIG. 95

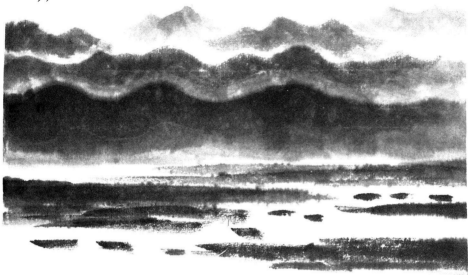

Song and Yuan artists often painted ranges of hills behind and beyond each other, gradually vanishing into the horizon (FIG. 95). When learning this method you might do a lotus-leaf texture first as a rough sketch, then go over it with a large brush dipped in ink (FIG. 96).

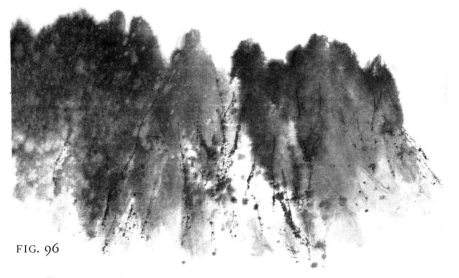

FIG. 96

Painting a distant hill is sometimes called ink-washing. Irrespective of the degree of absorbency of the unsized *xuan* paper, begin by loading a large brush with light ink, then dip it into thin, heavy, or even thick ink. After stirring it slightly in a plate so that the thicker ink is soaked halfway up the tuft, quickly do the figure of a flat inverted V (八) by means of two sweeping strokes to the left and right. The tip of the brush should point outwards when you do these strokes, that is, the side and root of the tuft should be

nearer to you. In this way, the upper part of the hill will be in thick or heavy ink, the middle part in thinner ink, and the foot of the hill in light ink. After the two sweeping side strokes have been done, quickly add a few vertical strokes while they are still wet so that the two layers of ink will blend into each other. If the vertical strokes are added after the first strokes have dried, the ink will have a dull, unnatural appearance. Beginners are prone to fail when trying to paint distant hills in this way, but constant practice will help.

BOATS, BRIDGES, CITIES, HOUSES, TEMPLES, PAVILIONS, PAGODAS, WALLS, CITY WALLS AND OTHER ORNAMENTAL OBJECTS

Ornamental objects (FIGS 97–100), done well, can have the same uplifting effect in a landscape painting as green leaves in a painting of peonies. Such objects should be depicted in sizes that harmonize with the mountains and rivers. They can be done with a pointed brush or a stump one, and their lines

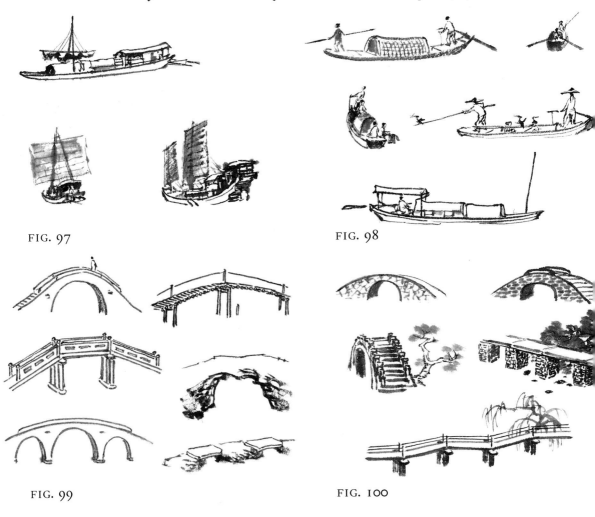

FIG. 97

FIG. 98

FIG. 99

FIG. 100

may be continuous or broken, with variations in width. Small figures in a boat must be depicted simply but vividly; this calls for skill in doing sketches.

Sails in a landscape painting should blow in the direction of the wind, that is, in the direction towards which the tree-tops bow and the ripples move.

The houses and terraces in FIG. 101 were delineated with a stump brush, but the houses, temples and pagodas in FIG. 102 were done with a pointed one. The closely-packed roofs in the upper part of FIG. 102 were executed with the brush held obliquely, which produced the needed momentum for shaping the roofs, whose contours need not be too distinct. The ridges of the roof of the palatial building in FIG. 103 were done with thick strokes and thick ink to render them more conspicuous. The little house with a thatched roof in the upper right corner of FIG. 104 was done with very simple strokes; it serves as a minor ornament.

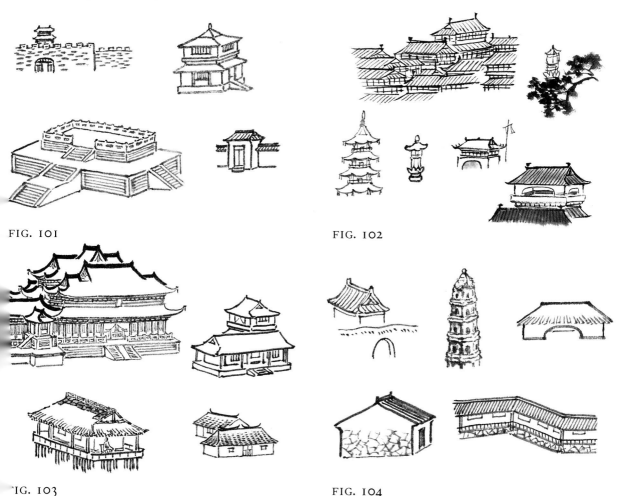

FIG. 101

FIG. 102

FIG. 103

FIG. 104

Reeds, grass, vines, trailing plants, caltrops, lotus, duckweeds, algae

FIG. 105 shows different ways of painting reeds. The clump in the centre, painted with vigorous strokes, is in the Northern style. In FIG. 106, the two upper rows are of different kinds of grass. The third row is of large and small duckweeds; a small dot in gluey ink can be added on the larger weeds as shown in the group on the left. Pinkish yellow dots look well as duckweed flowers, if flowers are needed. In FIG. 107, the left-hand picture is of wisteria on a frame; note that the vines must hang and twine naturally, with variations in thickness and density. To achieve such an effect, you must hold the brush loosely and trace out the vines as freely as possible, but terminate each stroke firmly.

Lotus blooms and leaves, portrayed as they usually appear in a landscape painting, are shown in the upper part of FIG. 108. The leaves must not lean too much to either side, and their veins must not be too distinct. There needn't be much variation in the shape of the blooms. Do the leaves, then the blooms, and then some more leaves – in all cases, the nearer the larger, the farther the smaller. Lotuses can be depicted with double outlines, with or without colours, or with ink and colours. In the lower part of FIG. 108 are the leaves of caltrops, depicted as groups of elongated dots that combine into heaps of varying density, a method that can also be used for lotus leaves.

FIG. 105

FIG. 106

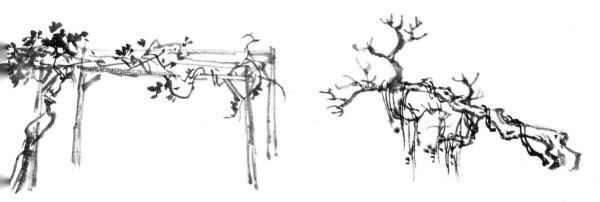

FIG. 107

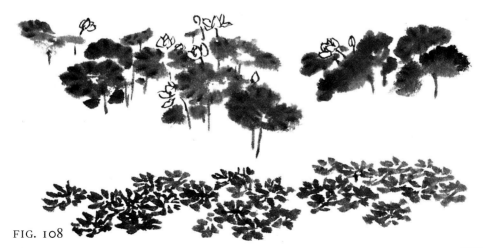

FIG. 108

FIGURES

Figures are often included in a landscape painting. Sometimes they are depicted in detail; sometimes they serve merely as ornaments. Besides the face, hair, hands and feet, ancient painters also paid special attention to the folds of a garment. In FIGS 109 and 110, the folds are depicted with lines of varying width. The impression is that the garments are blowing in the wind. The first figure in FIG. 111, a lady with a vase, is in the style of the Ming artist Chen Laolian. The last figure, a young boy, is an example of the *gongbi* style. FIGS 112–14 are examples of figures that serve only as ornaments in a landscape painting. Only show the general appearance of such figures; do not portray them very distinctly. In fact, if they were portrayed distinctly, they might not harmonize with the landscape.

FIG. 109

FIG. 110

FIG. 111

FIG. 112

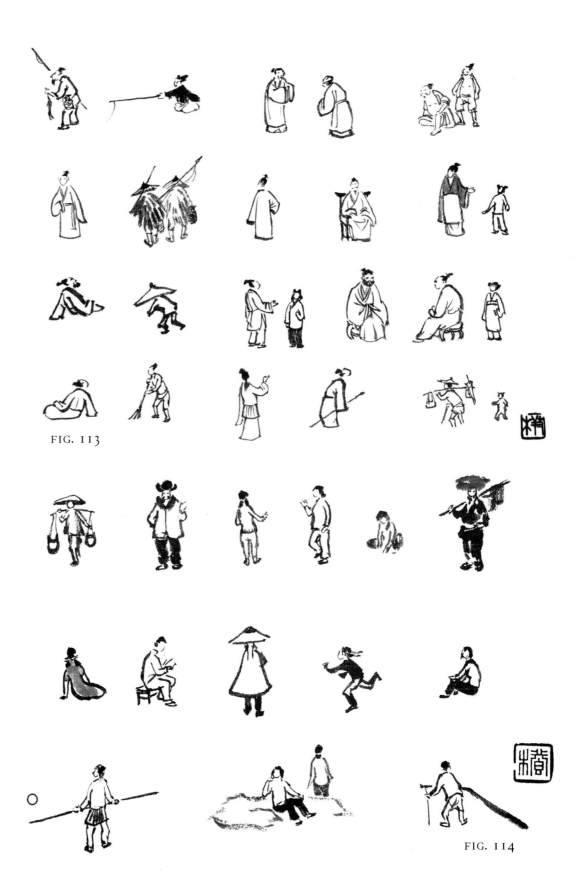

FIG. 113

FIG. 114

RAIN SCENES

Two kinds of rain scene are often depicted in landscape paintings: 1. thunderstorms and 2. light drizzles or the initial clearing after rain. When painting a thunderstorm, begin by drawing several thick oblique lines across the paper, using a large brush soaked in thin or light ink. The lines should be approximately parallel but do not have to be of the same length; nor does it matter if the ink spreads and the lines fuse into each other. When they are half dry, put in the hills, woods and houses between the lines or on other blank spaces with a brush that is dripping wet. Be sure that your trees bow in the right direction, that is, in the direction of the oblique lines, which represent rain blown sideways by the wind. Besides using splashed ink, you can also use dots for both moss and texture, making no distinction between the two, a technique used by Mi Fei and his son (*see* p.66). FIG. 115 is a rain scene in Mi Fei's style. It was not done entirely with a wet brush. When dotting, you can go over your strokes, but be careful not to cover up the original dots completely.

FIG. 115

NIGHT SCENES

FIG. 116 is a night scene with a bright moon behind the trees. The sky is covered with thin ink washes, leaving only a circular blank space to represent the moon. Another way of depicting the moon is to draw a faint circle in the sky. In FIG. 117, there is no moon but a night effect is created by the strong contrast between light and shade, black and white, on the rocks, spring and beach, and by the greyish hue of the sky done in very light ink. The impression is that the rocks are bathed in moonlight.

明月松間照清泉石上流 義木 [seal]

FIG. 116

義木 [seal]

FIG. 117

SNOW SCENES

A painting of a snow scene generally includes a grove or forest of dormant trees but very few moss dots. Only certain parts of the base of rocks are textured, and this is done with a few strokes in thick and gluey ink. The larger the exposed (textureless) surface of a rock, the thicker the snow will seem. The contours of rocks should be done lightly; in fact, distant rocks need not be contoured at all.

It is better to trace out the contours of snow-covered hills lightly with a pencil, the marks of which can be erased when the painting is finished. Charcoal should not be used because its marks are hard to remove; they become even more conspicuous when the paper is mounted. Trees and woods should be painted with gluey or thick ink. Sky and water, which may be done with heavy or thin ink washes, are painted last. If you are painting a scene of woods in front of snowy hills, or of hills beyond hills, apply some ink washes around the trees and at the base of all the hills. This treatment will show up the snowy trees and hills to better advantage. The impression of snow is not lost even in those places where ink washes have been added. If some colouring is deemed necessary, add touches of umber on the tree trunks and if there are any windows in the picture, on these also.

FIG. 118 is a painting in the Southern style. There are breaks in the lines that represent twigs and branches. The trunks of some trees are coated with

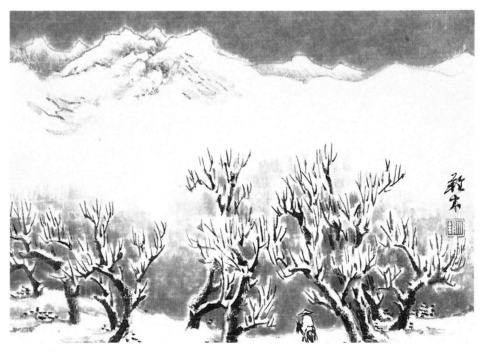

FIG. 118

85

thick ink on one side only so that when washes are added around them they appear to be laden with snow. Be careful not to apply too many strokes in such paintings. FIG. 119 is in the Northern style. In this painting there is a clear contrast between light and shade on the rocks and hills. Splashes of ink coupled with large blanks on the surfaces of rocks have produced a good snow scene.

To depict falling snow, splash alum onto the paper first. After it has dried, paint your picture and add ink washes. The parts splashed with alum will not take ink, so your painting when dry will be a dark and gloomy scene scattered with white dots like snowflakes. Alternatively, just paint the snow with white after the rest of the painting has been completed.

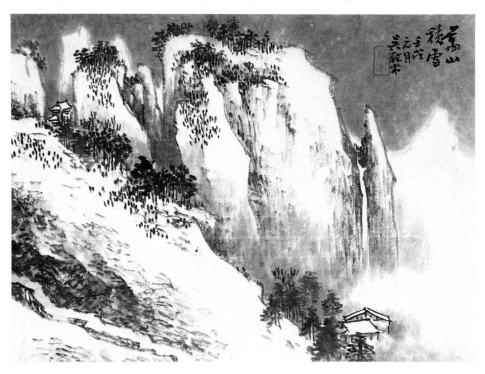

FIG. 119

INVERTED SHADOWS OR REFLECTIONS

FIG. 120 is a painting of the Lijiang River in Guangxi Province. The reflections of the mountains in the river were done in the modern way, made with vertical strokes in slightly different shades of ink, following the contours of the mountains. In FIG. 121 the reflections were done in the traditional way in thin ink, and the structure of the mountains, the trees and rocks is visible. Houses and terraces, if any, must be shown in the reflection too and they should be done with a ruler (*see* p.106).

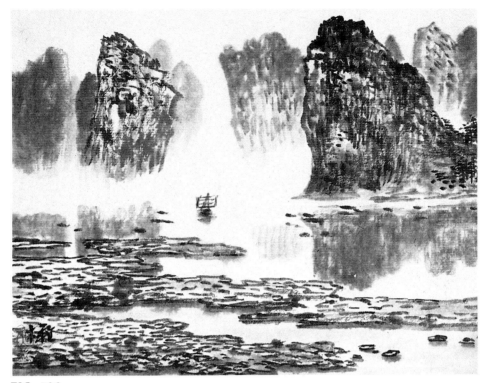

FIG. 120

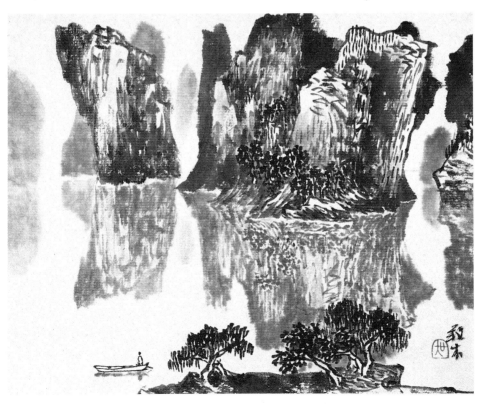

FIG. 121

87

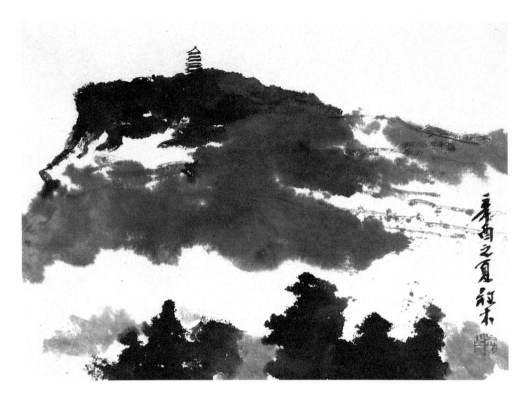

FIG. 122

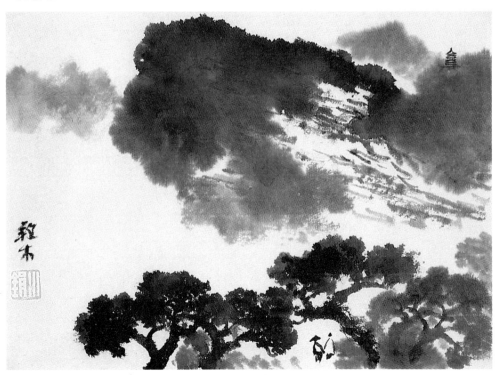

FIG. 123

Splashed-ink technique

This technique is often used by Chinese painters, ancient and modern, whether doing figures, landscapes, or flowers and birds. To splash means to use ink boldly and generously. The usual way is to spread dark and light shades of ink over the paper, or parts of it, as the base; then to apply gluey ink over large areas to heighten the effects. The latter, however, must be applied in the right places, so you must think and plan your work carefully beforehand. FIGS 122 and 123 are examples. Only unsized *xuan* paper and newly ground ink should be used.

Painting with gluey ink

This can be done with just gluey ink or with gluey ink and a very small amount of thick ink. FIG. 124, a painting of a bank of the Shujiang River, is an example. The brush must be wielded boldly and vigorously and the trees, rocks and moss completed in one go. Some artists of the Ming dynasty did very large landscapes in gluey ink. They used a dragon-scale texture (*see* p.41) and put in dots with a stump brush. You can learn much from such paintings.

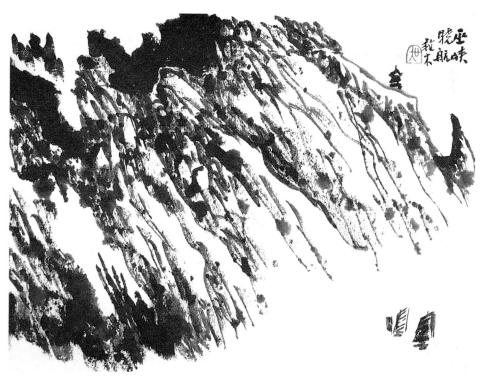

FIG. 124

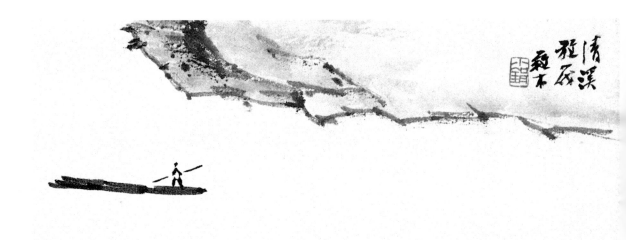

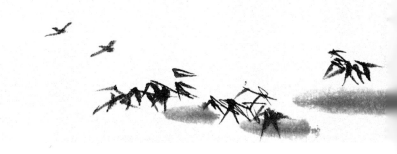

FIG. 125

MINIMAL BRUSHWORK TECHNIQUE

This is painting with the smallest possible number of strokes, the criterion being the fewer the better. FIG. 125 is an example in the Northern style. A very large part of the painting has been left blank, yet the presence of a body of water is strongly felt. FIG. 126 is of a south China scene. The empty space around the narrow strip of land represents the famous Tai Lake that lies between Jiangsu and Zhejiang Provinces. The extraordinary skill required to do this kind of painting has been summed up in the saying, 'Not a single stroke may be added or omitted'.

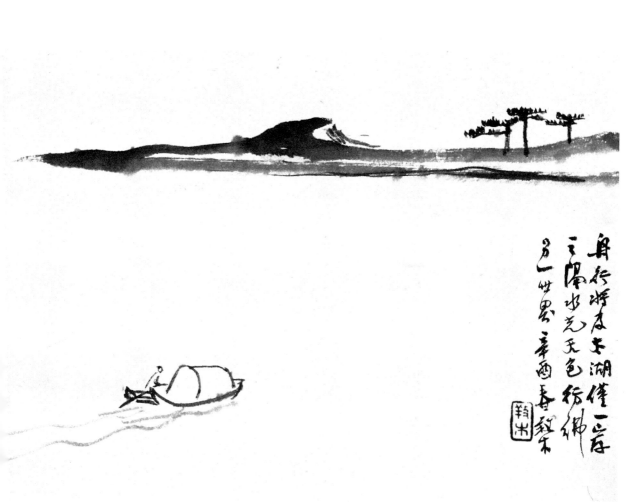

FIG. 126

THICK BRUSH TECHNIQUE

The number of strokes is not important but they should be vigorous and executed using a thick brush. FIG. 127 is an example of a painting completed in just a few strokes, but FIG. 128, consisting of objects arranged at different heights and distances from the viewer, required a larger number of strokes. The latter is patterned on the style of the Ming artist of the Wu school, Shen Zhou, nicknamed 'Thick-brush Shen'. Modern artists often use this technique, especially when painting high mountains on long scrolls, for which a thick brush is best.

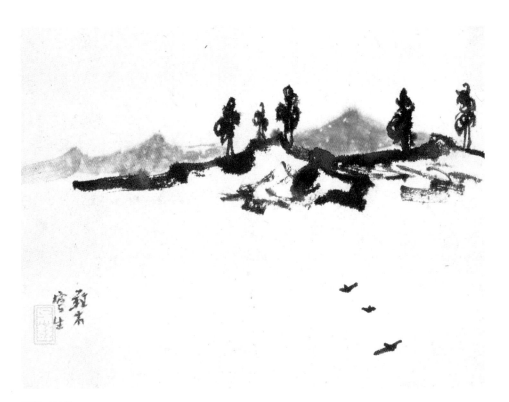

FIG. 127

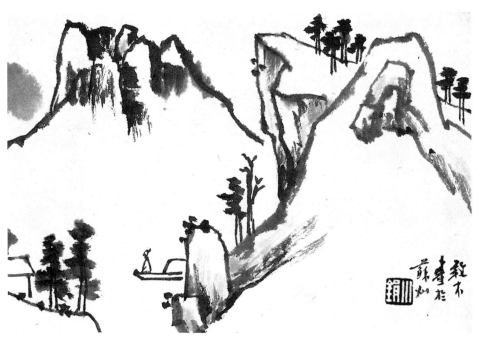

FIG. 128

DRY BRUSH TECHNIQUE

This involves using a brush with only a little water. The trees and rocks have to be textured and contoured a number of times. When finished, your painting should have a dry but smooth appearance; it must not look dull. FIGS 129 and 130 are dry-brush paintings.

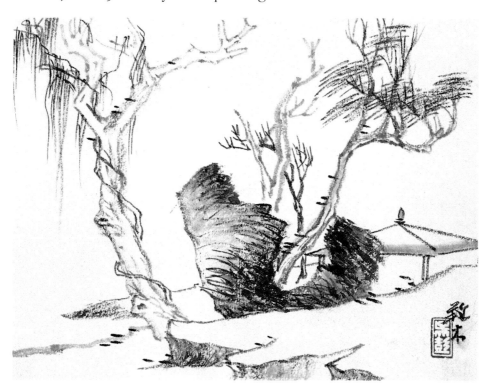

FIG. 129

FIG. 130

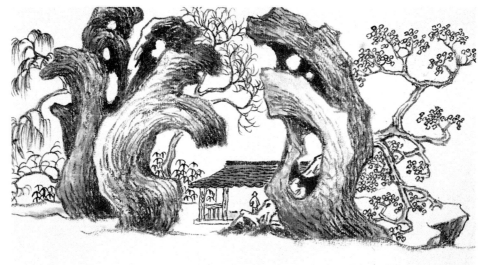

'Gongbi' and 'Xieyi' techniques combined

A painting done in this way is characterized by both bold brushwork and meticulous delineation. In FIG. 131, the houses and pavilions have been done in detail, but the trees and rocks are in a freer style. In FIG. 132, the leaves on

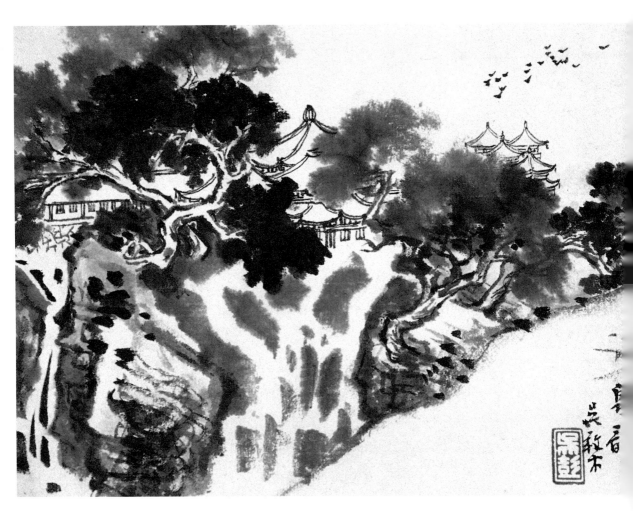

FIG. 131

the trees were minutely done with small pepper-like dots, but the textures and contours of the rocks and hills were painted by the thick-brush technique of the Southern school. The two contrasting styles match each other in a charming way.

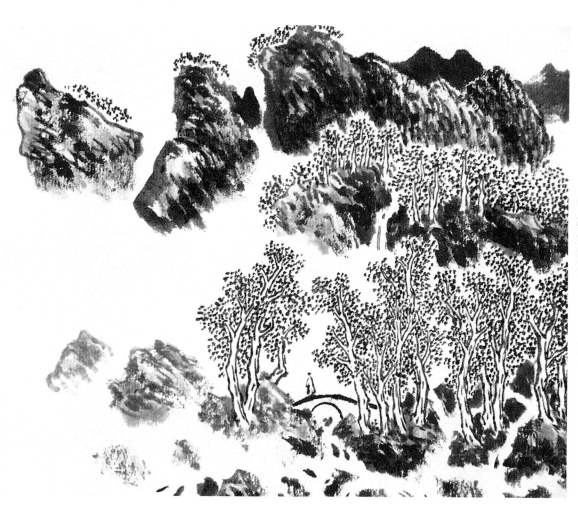

FIG. 132

Use of reddish brown

True colouring is one of the six principles of Chinese painting (*see* p.9). There is no fixed rule on the order for painting colours. Trees, rocks and hills may be coloured in any order, but moss dots, as a rule, should be put in after the others have been done.

Reddish brown is the best colour to use for autumn scenes. While different colours may be used for scenes of early, mid and late autumn, umber is generally the principal colour. Other colours that may be used are a watery green, indigo, blackish blue, greenish red, mineral blue, vermilion and lavender. Beginners, when practising, might try using ink and umber to produce the effects of reddish brown. These should be applied in different shades. Other colours may be added but ink and umber should remain the chief ones. At first glance there may seem to be only two colours, but actually there is endless variation. The first application of colours should be fairly light. The second application should darken or thicken those parts that need it. The third should consist of just a few finishing touches to further darken certain parts and give more spirit to the picture. If three applications still do not produce the desired effect, go over parts of the picture with a dark umber or add texture lines at the base of the rocks as in FIG. 133. In FIG. 134 indigo and umber are the principal colours, the others being auxiliaries. Indigo was used on the upper part of the mountains and umber on the lower part. This creates the impression of dusk descending.

In FIG. 135, the surfaces were coloured with indigo mixed with mineral blue, and umber was used for the rock base. This is a typical early autumn scene.

In FIG. 136, indigo and umber are the principal colours. The artist did not concentrate on any particular tree or rock but applied the two colours in large washes on the trees and rocks, allowing them to seep and spread on their own.

In FIG. 137, the two principal colours are umber and watery green. Both were used on the base and surface of the rocks, but there is more green on the left and more umber on the right. Though there seems to be much variation in colour, there is no confusion and one senses the presence of many intermediate colours.

In FIG. 138, the principal colour is blue-purple. Though a fairly large amount of umber was used, it has been covered up by the other colours. This is a painting in which cold colours dominate. It is a method suitable for depicting scenes in late autumn or early winter. When painting distant mountains in a scene like this, try dipping the brush in blue paint first and then in umber; this produces a mixed colour that resembles the faint glow of sunset.

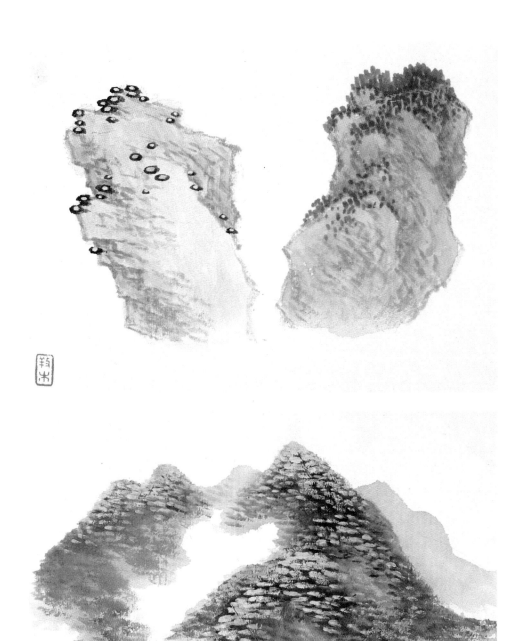

FIG. 80: Moss like inlaid gems (top left), cinnabar moss (top right), mineral green moss (bottom).

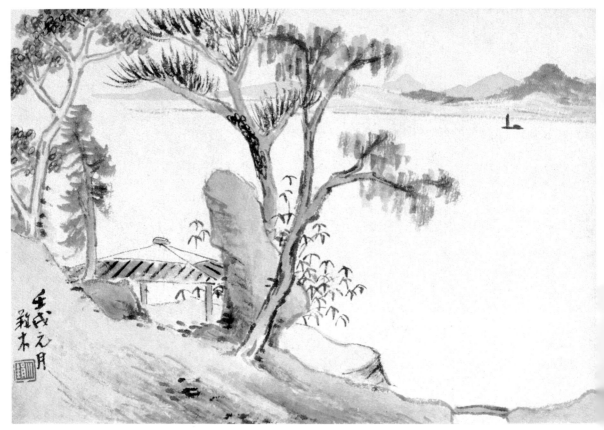

FIG. 133

FIG. 134

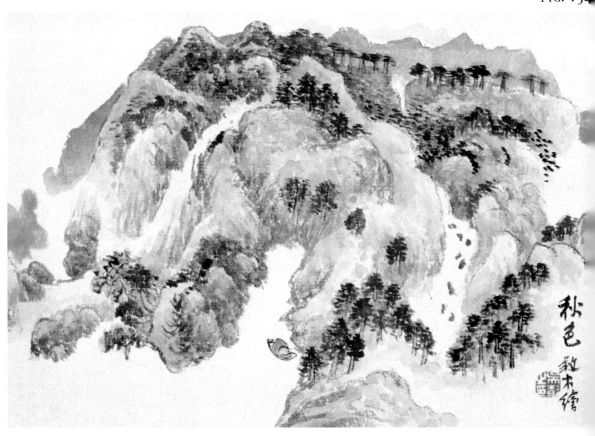

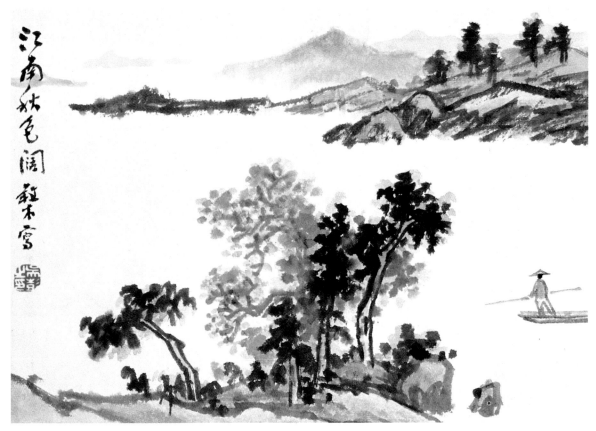

FIG. 135

FIG. 136

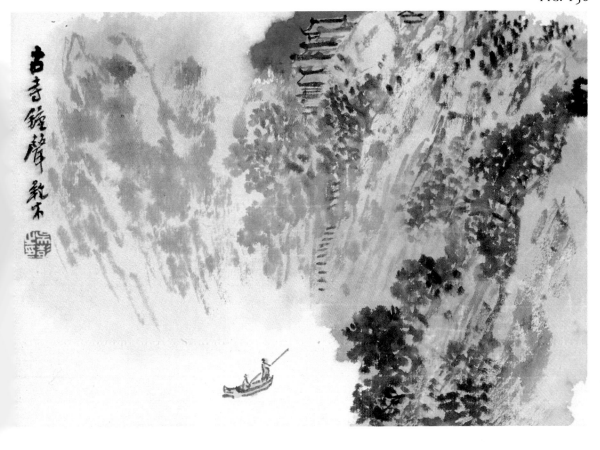

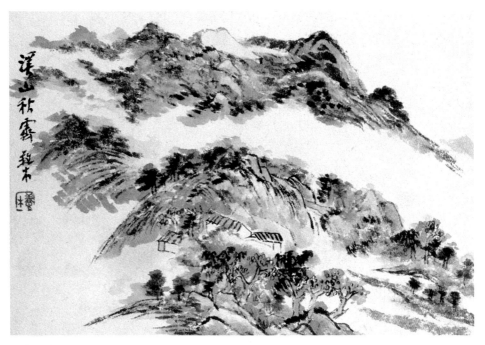

FIG. 137

FIG. 138

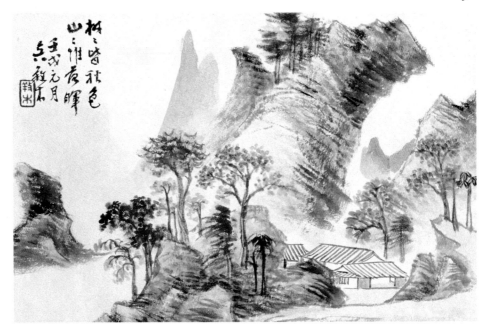

TECHNIQUE OF PARTIAL COLOURING

After you have painted a landscape in ink, you may want to add colours but not want them to obscure the ink parts. A technique used in such cases is called partial colouring. It consists of applying touches of umber on trees,

stone steps, wooden bridges, doors, windows and distant hills, as in FIG. 139. In FIG. 140, besides umber, a small amount of indigo has been added on the rocks to give a cool feeling to the painting.

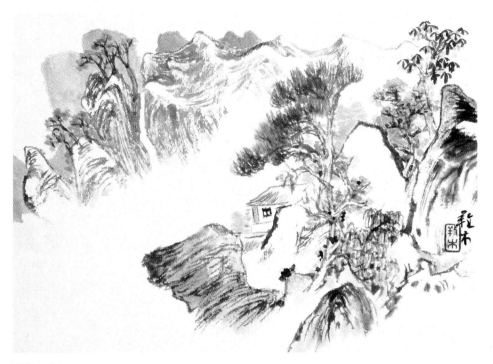

FIG. 139

FIG. 140

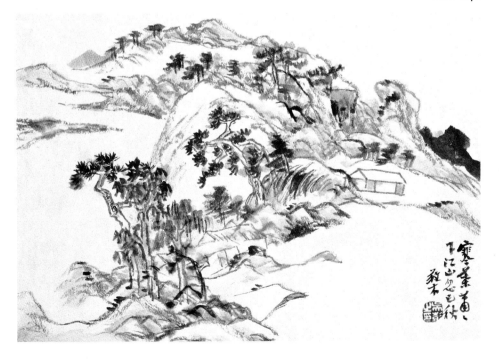

Blue-green landscapes

There are two kinds of blue-green landscapes, called *da qing-lu* (great blue-green) and *xiao qing-lu* (small blue-green). The difference, however, is not in size but in colour. The colours of a great blue-green landscape (FIGS 141 and 142) are more brilliant than those of a small one (FIGS 143 and 144).

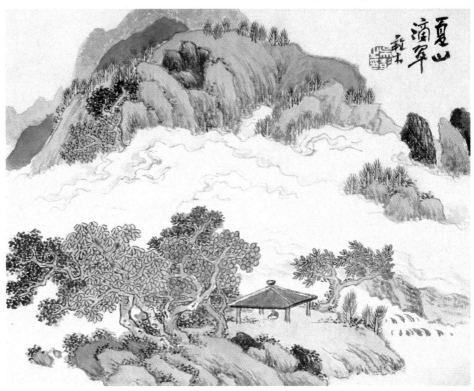

FIG. 141

The Song dynasty produced the best blue-green landscape artists. The two principal pigments used to do such landscapes are mineral blue and mineral green. A watery green can be used for moss dots. The rock surfaces can be either blue or green, but the base should be light umber. The trees, or the rocks and hills, may be coloured first, with moss dots added later. In some blue-green landscapes, only mineral green is used; but in great blue-greens, it is more common to use both pigments (*see* FIG. 141). If a finished painting looks garish, do not go over it with ink washes. Use a light solution of umber, and if one coating is not enough, apply a second coating when the first has dried. This will remove the garishness. When painting with mineral green, do not apply more than two or three coatings of this colour; too many coatings may give the painting a greasy appearance. It is good to include in the landscape a number of trees with outlined leaves which, when coloured, enhance the beauty of the landscape.

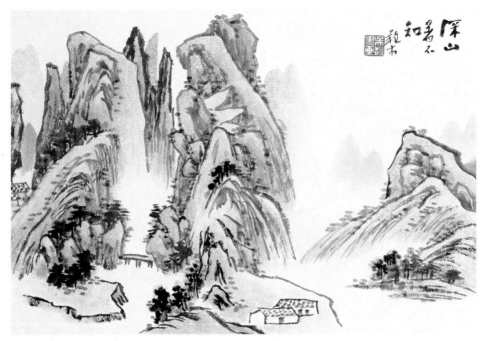

FIG. 142 (above) is a landscape painting without mineral blue. FIG. 143 is a small blue-green that may represent a spring scene. FIG. 144 is also a small blue-green, in which light purple has been added to the base of the rocks to prevent the painting being hackneyed, a method attributed to Wang Yuanqi (Wang Yüan-Chi) of the Qing dynasty.

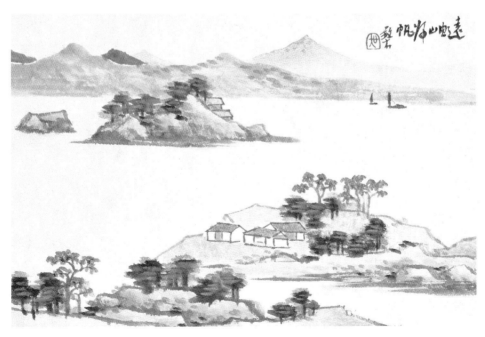

FIG. 143

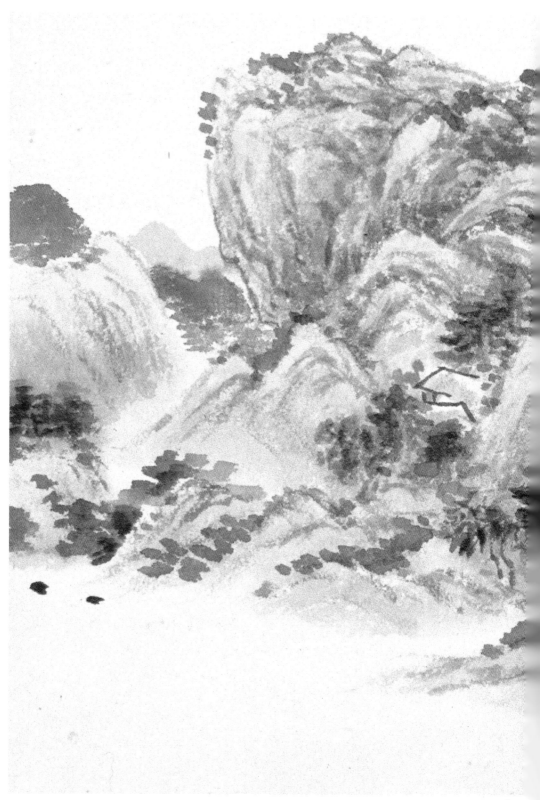

FIG. 144

翠岩
錦村

吳戴木
臺於
姑蘇

[印章]

'GONGBI' PAINTING WITH A RULER

Painting with the aid of rulers was most popular during the Song dynasty, but very few Song artists have left their names on their works. The three Yuans (Yuan Jiang, Yuan Yao, Yuan Xue) of the Qing are among the best artists of later periods who used this method.

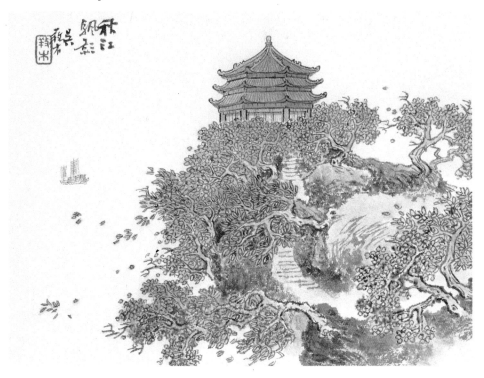

FIG. 145

Rulers of different sizes are needed to do such paintings, and the brush must be a small one with a pointed tip of stiff rabbit hair. When painting, place a second brush, upside down, alongside the one you are using. Hold the ruler firmly in place with one hand and the two brushes in the other. Place the lower end of the inverted brush in a groove in the ruler when you are drawing lines. This will keep the tip of the drawing brush in place as it moves along the edge of the ruler and you will be able to do straight and even lines. However, because a brush is flexible, the lines will look as if done freehand. You are advised to hold your breath while doing a long line or two parallel lines. Any inhaling or exhaling may cause the hand to shake and produce lines that are neither straight nor uniform in thickness. The length and position of each line should be gauged beforehand and trial drawings made before you actually start working. It may be advisable to mark the two ends of each line lightly with a pencil on the silk or paper first.

Houses and pavilions done with a ruler must be attractively structured. They must have both simple and complex parts, and the lines on the brighter parts must be thinner than those in the shade, to give variation. Part of FIG. 145 was done with rulers. Note that the perspective does not have to be very exact (*see also* p.111).

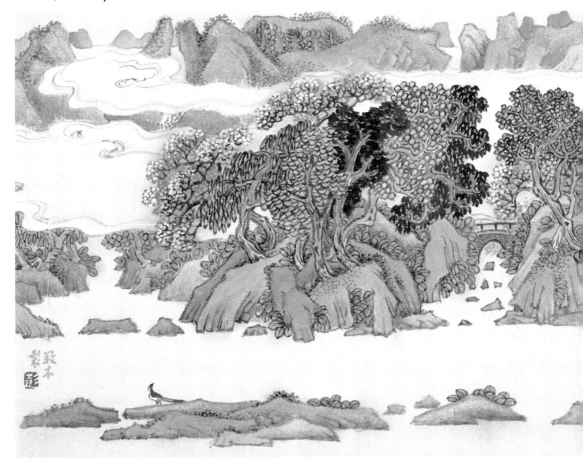

FIG. 146

GOLD AND BLUE-GREEN LANDSCAPES

This genre of landscape painting has a very long history, stretching back to the Tang dynasty. In general, there are two ways of doing such landscapes:
1. Add contours in gold (use rattan yellow) on a great blue-green (*see* p.102), mainly on the hills and rocks and on the lines of trees. Ripples can also be delineated or traced over with yellow. These landscapes are usually painted on paper of a dull blue colour, on which they look very bright.
2. Use yellow for both the textures and the contours of a great blue-green. Some yellow can also be added on the rock surfaces, but do not cover all the rocks with yellow. FIG. 146 is an example of a landscape painted in this way.

The 'meigu' (boneless) method

This method can be used to paint landscapes in either the *xieyi* or the *gongbi* style.

 Meigu xieyi landscapes are painted in the same way as other landscapes, except that colours are used instead of ink, as shown in FIG. 147. FIG. 148, *Beauty of Autumn*, has a more orderly composition. The bright red leaves are shaped like the character ' 介 ', and the hills are painted in indigo with some added moss dots in light red to match the red leaves in the foreground.

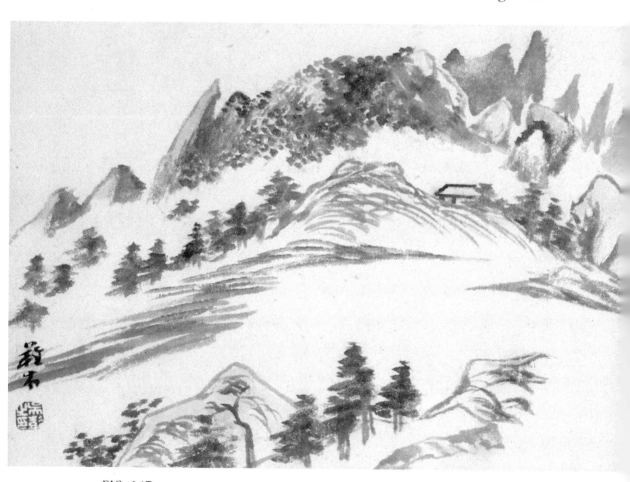

FIG. 147

Meigu gongbi landscapes are done in the same way as blue-green landscapes, except that ink is not used, there are no outlines, and the textures are in colours. The rocks are depicted clearly; even the petals of wild flowers growing in the mountains are very distinct. Methods of colouring such as *ʒhao se* (undercoating with alum), *bei fu* (colouring the back) and *tuo di* (coating the back) can also be used (*see* p.24). It is difficult to do a *meigu gongbi* painting on unsized *xuan* paper. Silk is much better.

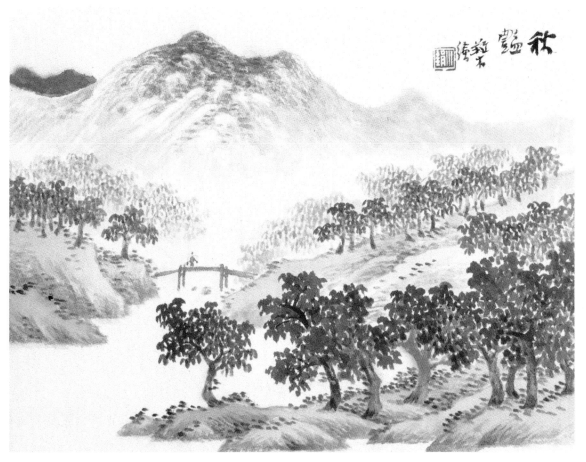

FIG. 148

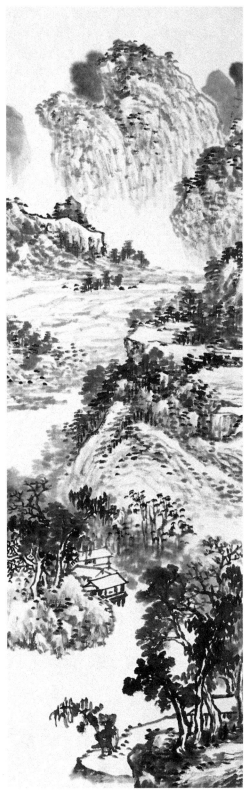

FIG. 149

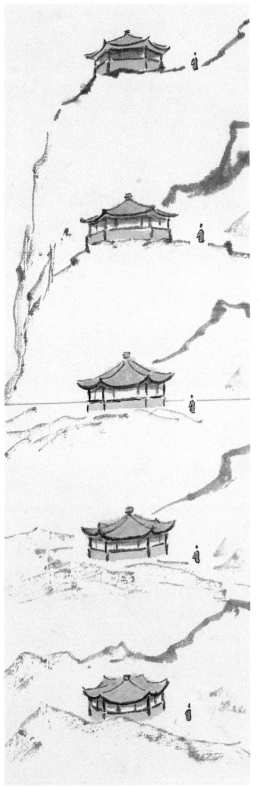

FIG. 150

Perspective and proportion

A special characteristic of traditional Chinese landscape painting is its many-point, instead of one-point, perspective. Behind a mountain range another range may loom, with trees, houses and streams in full view, as in FIG. 149, irrespective of depth and distance, neither of which is portrayed realistically.

In a modern landscape painting, however, there should be a greater sense of reality, though the advantages of the many-point perspective should be retained as far as possible. The artist should first select a line on the paper to represent the horizon. FIG. 150 is an example. The two gazebos above the horizon are depicted as if they were being viewed from below; and the two below the horizon as if being viewed from above. The higher or lower the gazebo is in relation to the horizon, the more obvious is the sense of looking upwards or downwards. Correspondingly, the composition of the landscape should also show height and depth realistically. But smaller objects such as trees, rocks, figures and animals may be portrayed in the traditional way without regard for their positions above, below, or on the horizon; they will not look unnatural or out of place.

Proportion is not too important in Chinese painting. So long as the arrangement or composition is good, the basic requirements will have been met even if individual objects are out of proportion in size or quantity. Thus, just a few cherries may represent a basketful of fruit and the lotus blooms in a pond may appear to be several times the size of a human head.

Composition and general appearance

Good composition is the fifth of the six principles of Chinese painting (*see* p.9). It refers to the arrangement of parts or the structure of a painting which, if done well, adds much to the general appearance. Care should be taken to avoid such stereotyped composition as three trees to start with, a small bridge or pavilion alongside.

The composition of a Chinese landscape must have one of the following three kinds of distant perspective.

1. Level-and-distant perspective: its special feature is that however much the hills and water may rise and fall, twist and turn, they always extend horizontally into the distance. Rivers and streams are virtually indispensable in a painting of this kind (*see* FIG. 151).

2. Deep-and-distant perspective: this refers to a varied topography, one that includes dark ravines, secluded valleys, winding paths. The composition must represent both depth and distance as in FIG. 152.

3. High-and-distant perspective: this will usually include huge crags, cascades, hills beyond hills and peaks above peaks, as in FIG. 153.

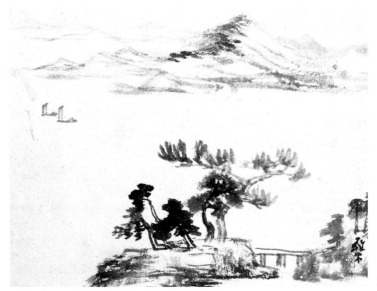

FIG. 151

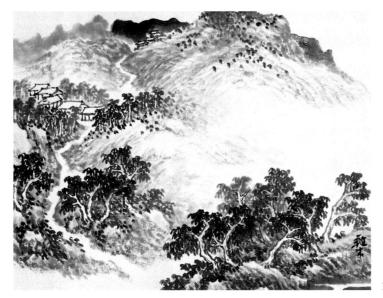

FIG. 152

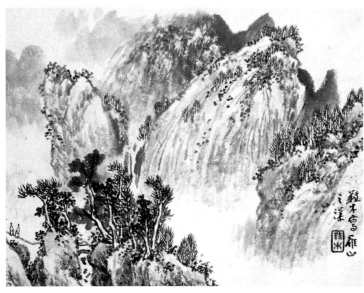

FIG. 153

There are various other ways of structuring a landscape as shown in the illustrations 1 to 12:

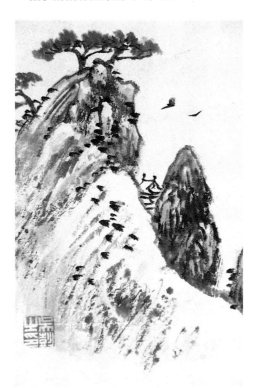

1. Only the upper slopes of the mountains and peaks are shown.

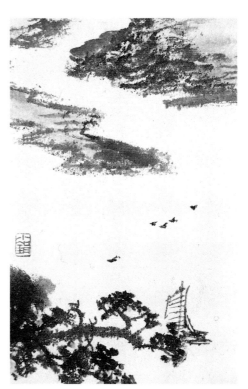

2. Only the lower slopes of the mountain are shown.

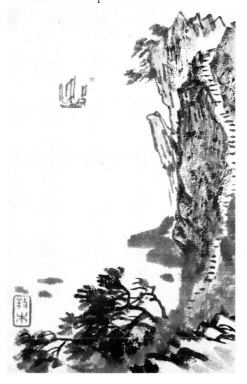

3. The subjects are wholly or mostly on one side of the picture.

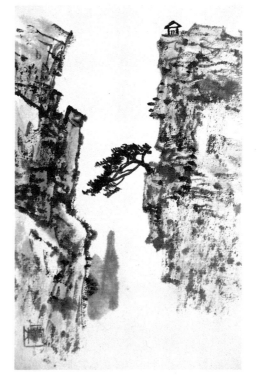

4. The subjects portrayed are at the sides; the middle part of the picture is blank or nearly blank.

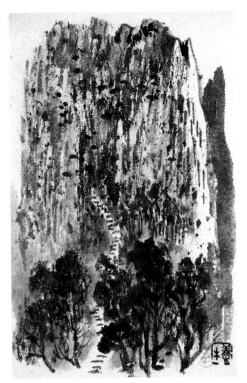

5. The whole picture is filled; there is hardly any blank space.

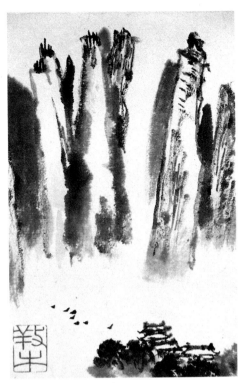

6. Most of the subjects are concentrated in the upper part of the picture.

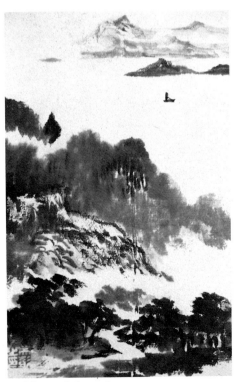

7. Most of the subjects are concentrated in the lower part of the picture.

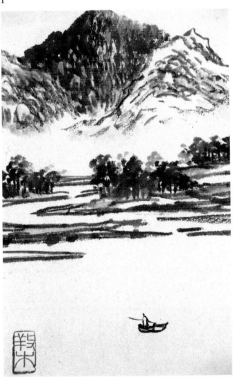

8. Virtually all subjects are in the upper part of the picture.

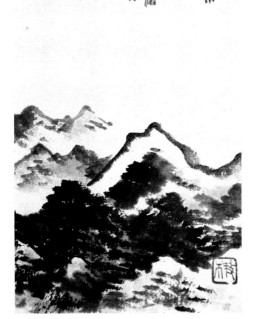

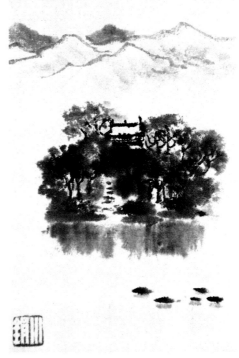

9. Virtually all subjects are in the
lower part of the picture.

10. The most important subjects are
in the centre of the picture.

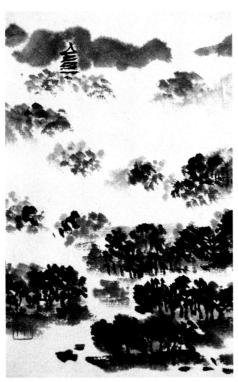

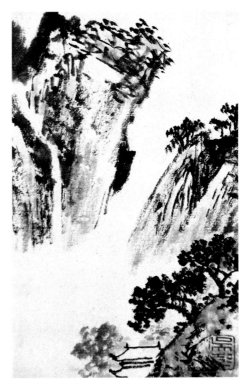

11. The subjects appear to be
scattered but are not fragmented; they
form an integrated whole.

12. The left and right sides of the
picture are balanced.

When a painting has been finished, it should be examined in various ways – at close range, from a distance, on a wall – to see if the arrangement of the subjects is clear and sensible, and if there are flaws in the composition or structure, or deficiencies in quality or quantity. Many alterations may have to be made before a painting can become a good work of art.

HAND SCROLLS AND FANS

A hand scroll is a long horizontal scroll that is usually rolled up when not being used. The painting is viewed by unrolling the scroll, a section at a time. In a traditional-style landscape painted on a scroll, the hills and rivers may vary in height, but the variation is determined not by their relative distance from the viewer but by their features. A short horizontal scroll, i.e. one that can be fully unrolled in one's hands or conveniently hung on a wall, is called a *heng-pi*, meaning horizontal hanging scroll. FIG. 154 shows a painting on a horizontal scroll. Called *The Shixin Peaks of the Huangshan Mountains*, it consists of three sections that present close-range, medium-range, and long-range views of the peaks, a method of artistic representation that conforms to the principles and composition of traditional Chinese landscape painting.

Most fans are shaped like part of a circle. In FIG. 155 the composition follows the shape of the fan: the landscape curves downward at the two sides. In FIG. 156 the landscape does not curve. Either method may be used. One thing you should remember is that the surface of a fan is often smooth and non-absorbent. Painting on such a surface is like painting on glass, so you muse be careful about the consistency of the ink and the wetness or dryness of the brush. FIG. 157 is a painting on a round fan, called a palace fan.

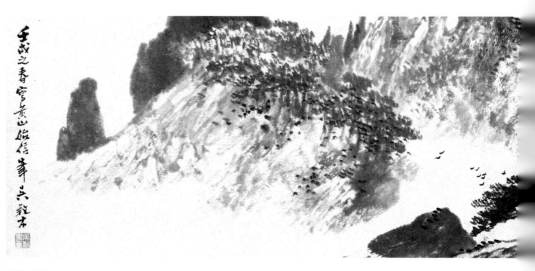

FIG. 154

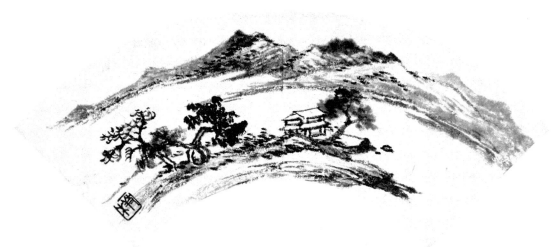

FIG. 155

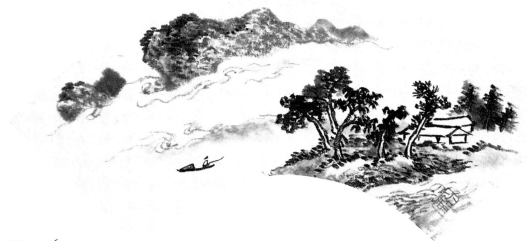

FIG. 156

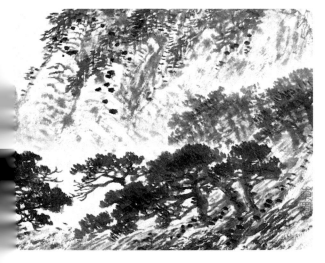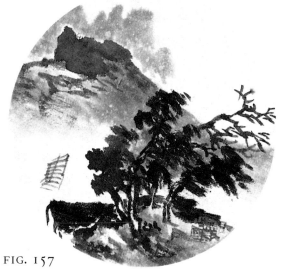

FIG. 157

117

POINTS TO REMEMBER

After years of practice, a professional painter will be experienced and have formed certain basic ideas about his style. And as in any other profession, not all painters will form the same opinions on what is best. Therefore, the points that I have listed below are only my personal opinions.

1. A painter must give all his attention to his work. If he does, it will be easier to correct any mistakes that are made.

2. Good brushwork is a combination of firmness and flexibility, strength and softness. Brushstrokes must not be stiff or abrupt.

3. If you are learning Southern brushwork, make your lines firm but pliant like ropes.

4. In a Southern landscape there is some curvature in every stroke. Both edges of the lines forming the contours look downy. But in a Northern landscape, only the inner edges of such lines look downy; the outer edges are smooth.

5. When learning, you may occasionally execute a fine stroke. This is a sign of progress, and though you may not be able to repeat it at once, you will after some practice.

6. The moss dots on a mountainside should be spaced densely or sparsely along a 'vein', an imaginary line leading tortuously to the top of the mountain.

7. In order not to distract attention from the dominant theme, the four corners of your painting should be more or less blank. It is like disregarding the sides of a road so as to keep your eyes on what lies ahead.

8. Use the *pian feng* (side stroke) more. Add some *zhong feng* (centre strokes) later.

9. Brushstrokes are like blows in boxing, in which if one blow does not land you follow it with another. Progress comes with practice.

10. Producing a downy appearance by seepage from a wet brush is a skill indispensable to Chinese painting.

11. Do not be afraid of breaking with convention, but this does not mean be slapdash. Strokes done in that way are nearly always faulty.

12. Using the brush briskly should be like rending silk, not splitting bamboo. A stroke made like splitting bamboo is also a faulty one.

13. When doing pine trees, it is best to load the branches thickly with fine twigs and then add the needles.

14. When you are painting the slopes of a large peak or mountain, you get different results by standing up than if you are sitting down.

15. When doing a series of dots, take care that they do not appear serrated like this: ᵛᵛᵛ .

16. When learning to paint, first try to create harmony in your picture, that

is, let no part of it look harsh or stiff. Then break this harmony by going over the parts that need retouching and achieve a new harmony with more touches.

17. When doing a series of terraces on a slope, make sure that the lines marking the outer edges of the terraces are parallel to each other and to the top and bottom edges of the paper. No line should slant upwards or downwards.

18. Moss in the crevices of rocks may be depicted in an orderly way, but that on the surfaces of rocks should not be painted too regularly. If there is to be a building beside a rock, add moss dots on the side of the rock first.

19. When painting, always keep the paper parallel to the edge of the table. Otherwise, you may find that your landscape tilts to one side.

20. Leave plenty of blank spaces in your painting. After washes and textures have been added, the blank spaces may not look very large, but remember, space is an essential element in the composition of a Chinese painting.

21. Even if your interest is in flower painting, it is better to learn some landscape painting first because it makes flower painting easier.

22. In order to heighten the sense of space and distance use thick or gluey ink to paint the mountains and water in the foreground of a painting; use thinner ink for those in the middle ground and light ink for those in the background. The summit of a mountain may be accentuated with thick ink.

23. Ink washes need not be added to an ink landscape if the overall concept has been expressed well and the brushwork good.

24. When deciding what the principal colour of your painting should be, take note of the amount of ink that has already been used.

25. Always be ready to give up old concepts and accept new ones. This is the only way you can make progress.

26. Dry, wet, thick and thin ink should all be used to give a sense of rhythm and harmony.

27. Do not choose scenes for painting as you would for photographs. Traditionally, Chinese painting has not been strictly representational, the idea being more to convey the spirit of the subject.

28. Do not put too much detail in your sketch; it might inhibit the use of the brush.

29. There are five consistencies of ink (*see* p.14), but it is unnecessary to use them all.

30. Think and plan your work carefully, but use the brush boldly and resolutely.

IMITATION, PAINTING FROM NATURE, CREATIVE WORK

As described in the Introduction (*see* p.9), imitating, or copying, the old masters is the best way to begin, as long as it is not done too slavishly or for too long.

FIG. 158 is an imitation of Shi Tao's style (Ming-Qing era) and FIG. 159 an imitation of She Zhou's brushwork, an artist of the Wu school in the Ming dynasty (*see also* p.91). In the latter, the top of the pines and the lower part of the block of stone have been left blank. This method of painting, in which certain objects are omitted, is called 'turning the concrete into the abstract'.

Painting from life or from nature has long been practised by the old masters. Today, it is called sketching. The five paintings shown in FIGS 160–4 are sketches that have been slightly worked over. They are paintings from nature but are similar to creative work.

When starting a landscape painting, having completed your sketch, begin by doing the trees and scenes in the foreground, then the rocks that make up the middle ground, and lastly the background. Where moss dots are needed, they should be put in at the same time as you paint the different parts. Hills in the distance should be painted last, and if it is an ink landscape, they should be coated with light ink washes.

Thus, to produce creative work, you must first imitate the old masters, then practise painting from life and nature, not mechanically but with imagination, and develop new techniques and new methods of composition on the basis of traditional ones.

FIG. 165 is an example of a partially coloured painting. Its textures are in very thin lines. There was no need to add any moss dots because it already had a downy appearance.

FIG. 166 is a landscape with a broken-ribbon texture (*see* p.32) in which water, sky, mist and ripples are all left to the imagination. To paint the peach blossoms on the hillside begin with the stems, then add washes of red over them. When these have dried, put in the dots with white. After the dots are firmly in place, depict the shady parts of the flowers with dark grey, which will accentuate the brightness and beauty of the blossoms.

In FIG. 167, the moss is dotted with cinnabar (vermilion) and the leaves are tinged with red to harmonize with the moss. FIG. 168 is an example of a painting that consists largely of contours; there is very little texture. FIG. 169 contains some ink washes; its style is more Northern than Southern. FIG. 170 is of Guilin, one of the most beautiful places in China, and shows reflections of mountain peaks. The left side of the painting is fairly empty; the colours are concentrated on the right side and they have been coated over with large washes of light mineral green.

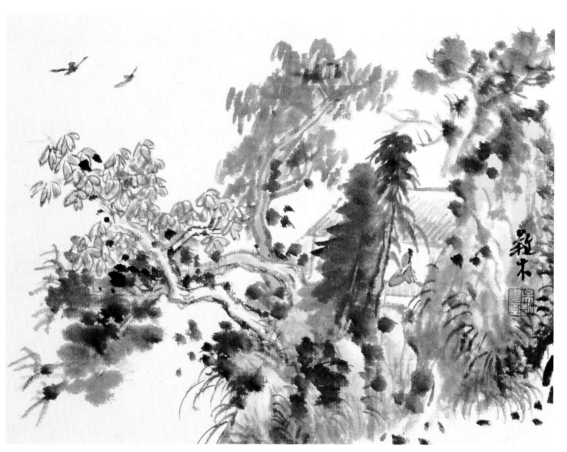

FIG. 158

FIG. 159

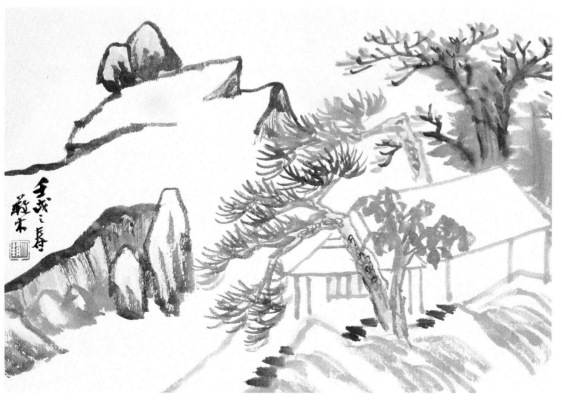

FIG. 160

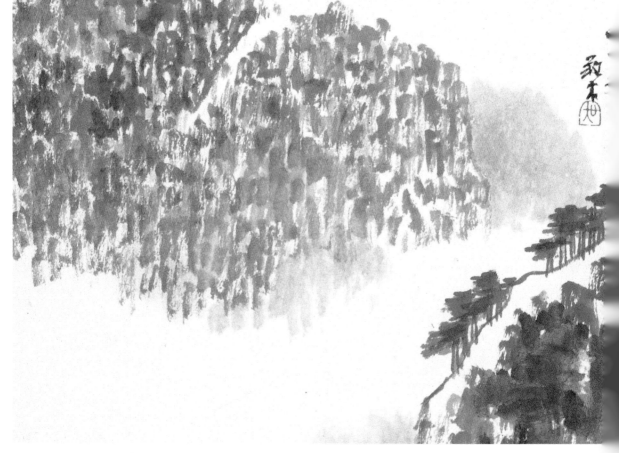

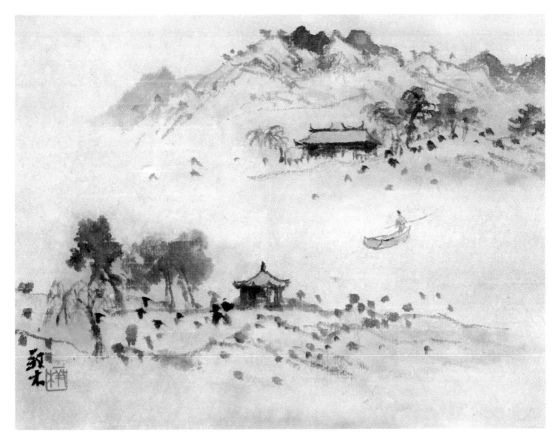

FIG. 162

FIG. 163

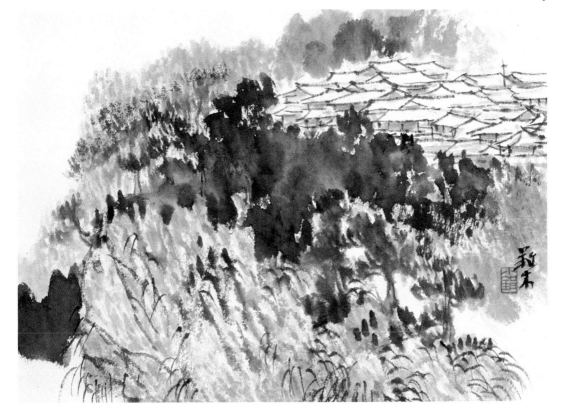

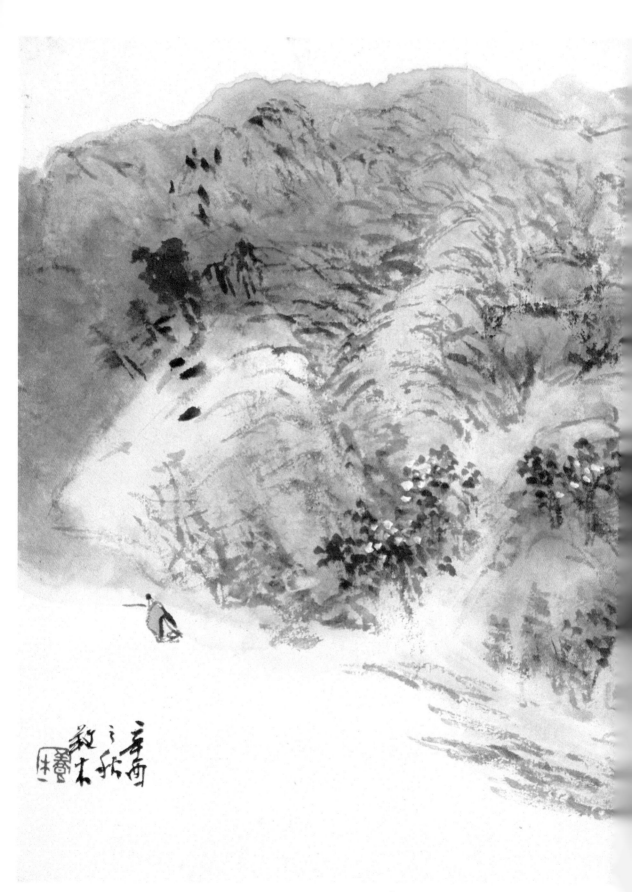

FIG. 164

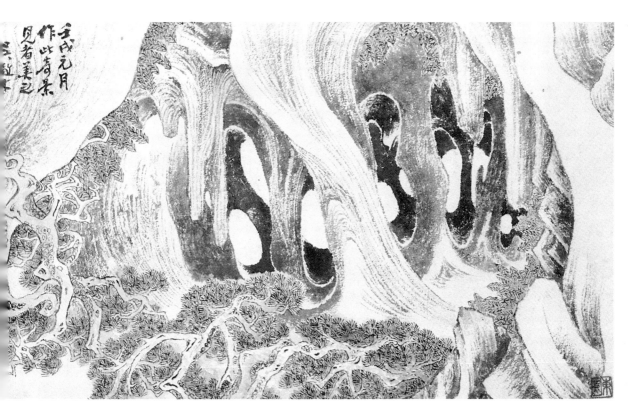

FIG. 165

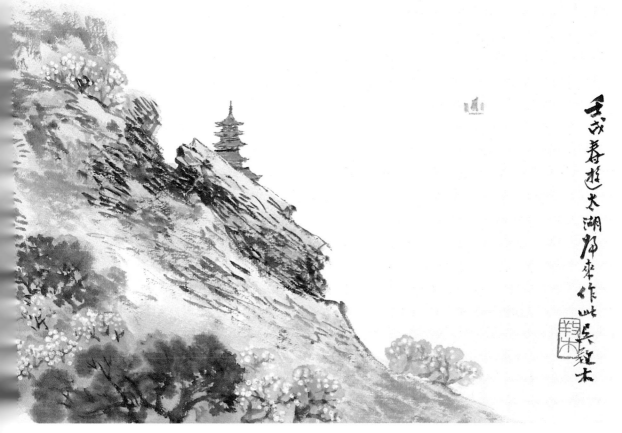

FIG. 166

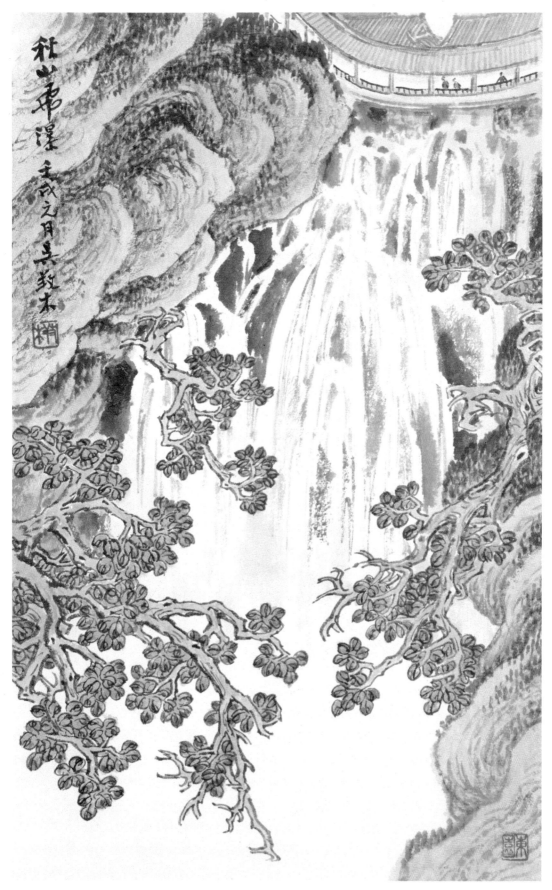

FIG. 1

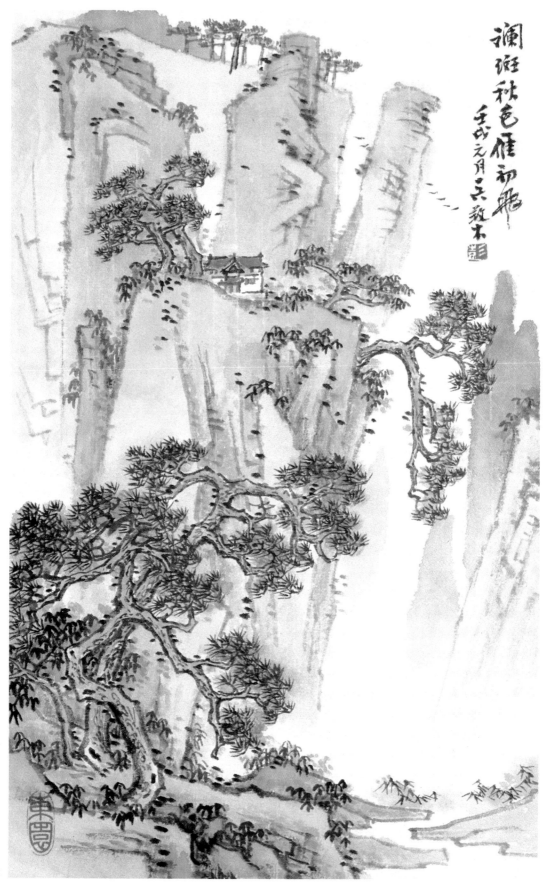

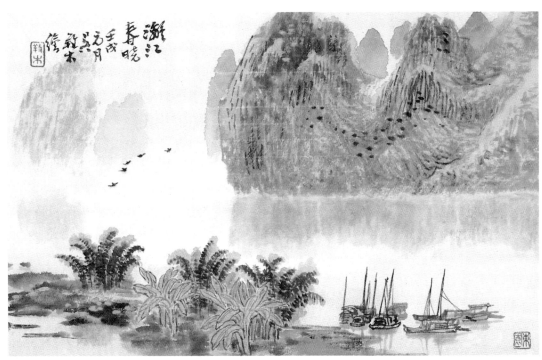

FIG. 170

INSCRIPTIONS AND SEALS

Before the Yuan dynasty, it was the custom for an artist just to sign his name on a painting. Sometimes there was no signature at all, and long inscriptions were exceedingly rare. But from the Yuan and Ming dynasties onwards, calligraphic inscriptions gradually became a means of enhancing the colourfulness of a painting, and the seal, originally serving only to show the artist's identity, became an indispensable part of the painting. The position of an inscription is very important and should be determined by the composition. One must bear in mind that while an inscription may be placed on a blank space, it must not appear on a space that serves some special purpose, such as to heighten the sense of space.

The same rule holds for seals: whether one, two or three are affixed should be determined by the composition. Never place a seal directly under the last line of an inscription written horizontally; nor should the seal be too large or too small compared with the characters of the inscription. Some of the old masters never affixed their seals on a body of water; they preferred to place them on rocks. Some artists used to affix a seal with their real name above and one with an alias or style below. Although there are no set rules, one should seek some reason for the position of these embellishments to a painting. If one is not good at writing inscriptions, it may be best just to sign one's name.

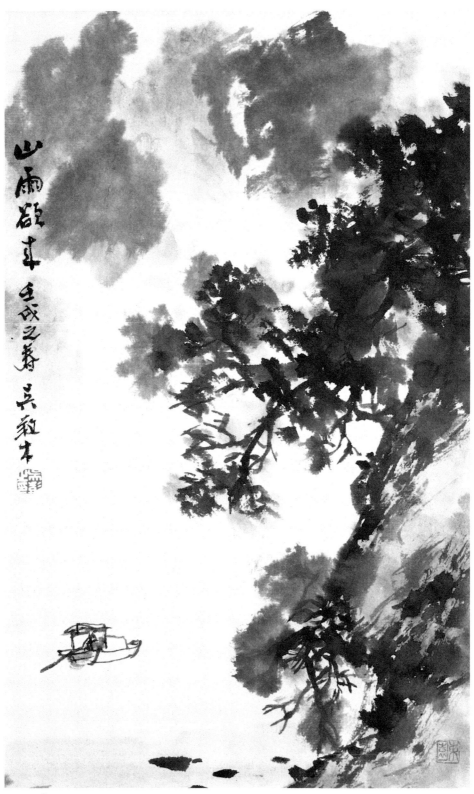

FIG. 169

Chapter 3
Flower-and-bird painting

CHOICE OF STYLE
There are numerous schools of flower-and-bird painting in China. Among the earliest and best known are those represented by Xu Xi and Huang Jucai of the Five Dynasties (907–60). Xu Xi's grandson, Xu Chongsi, was a pioneer of the *meigu* (boneless) way of painting flowers – painting with no ink lines. Many other schools and styles appeared during this period, following the establishment of an academy of painting.

USE OF BRUSH, INK AND COLOURS
When you are painting *xieyi* flowers, it is best to manipulate the brush with your arm or elbow in order to have greater freedom of movement. Irrespective of whether you are doing a flower, leaf, butterfly, or bird, you must note carefully the posture of the subject. When painting a trunk or a branch, you can use a brush with a blend of different hairs, but when painting leaves or flowers, use only a goat-hair brush. Pause slightly for accentuation when you bring your brush down, and make distinct turns. In order to make the lines of a *gongbi* painting smooth and even, you should use a wolf- or rabbit-hair brush. Flowers and leaves should be coloured carefully in layers, which is quite different from the use of large and small washes in landscape painting.

Flower-and-bird painters can learn from landscape painting much that is useful for their brushwork. The various kinds of strokes used in landscape painting such as *zhong feng* (centre stroke), *pian feng* (side stroke), *ni feng* (reverse or counter stroke), *lu feng* (open stroke) and *cang feng* (concealed stroke) can all be used to a greater or lesser extent in flower-and-bird painting (*see* p.20).

Both very dark and very light ink should be used. Do not be sparing in the use of ink, but do not overuse it either. Be sure that your brush has been washed clean. Load it with thin ink, then dip it in thick or gluey ink, so that dark and light shades can be produced in one stroke. This is one way of distinguishing between leaves and flowers in an ink painting.

There are four basic methods of using colour in flower-and-bird painting:

1. Filling in strong colours on a leaf or flower traced out with double lines.

2. Applying light colour washes. Used in *meigu* painting, also in colouring a double-line drawing.

3. Delineating or retouching with colour. Either to the lines of a flower directly with colour or go over the ink lines with colour.

4. Monochrome – painting in only one colour. It is similar in some ways to a *meigu* painting.

FLOWERS AND LEAVES

Flowers and leaves should be depicted in various positions on a plant – left and right; high and low; facing upwards and downwards, front and back.

To paint a flower with ink in the *xieyi* way, load your brush with both dark and light ink. When you bring the brush down on paper, the tip, with the thick ink, should be at the centre of the flower. Keeping the tip at the centre, rotate the brush as you lower it and you will sketch out the overlapping petals, of which the ones along the perimeter will be lighter and less distinct than those nearer the centre, however forcefully you bring down the brush. Reload the brush when the ink has been used up. Put in the stamens when the ink has half dried, with a flicking stroke using the brush tip.

Leaves are done in much the same way. A small leaf can be completed in one stroke, a larger one may need two strokes, and a very large one three or more strokes. In general, leaves should be darker than flowers (when there are no colours) so that they can be distinguished from each other. In addition, the ink should seep. Delineate the veins of a leaf with thick or gluey ink, or with thin or heavy ink if it is a tender leaf. Trace out the veins as you would trace the leaves of the willow or orchid. Start each stroke lightly, increase your pressure as you reach the middle of the line, then relax again at the end of the stroke.

Veins can also be delineated with a stump brush. They do not have to point in the same direction as the leaf itself. The principal vein extends lengthwise along the middle of a leaf; those on the two sides are the branch veins, which should be denser near the tip than in the other parts of the leaf. Sometimes it is only necessary to put in the principal vein on a small leaf. The branch veins of a small leaf, if delineated with a stump brush, can be symmetrical but do not have to be evenly spaced.

When painting a *xieyi* flower in colours, do not load your brush with more than two colours at a time. This is like dipping the brush in two shades of ink. The stamens can be depicted with ink or some dark colour resembling ink, and the pollen with white paint. When colouring leaves, load your brush with indigo or watery green first, then dip it in thick or gluey ink. Each stroke that you make will have a half-ink, half-colour appearance that suggests light and shadow. Large leaves may be depicted either from the

front or from the back; it is better to do the back views first and then the front views. The begonia, banana and fragrant plantain lily are plants with large leaves. The calyx and stalk of a flower are often dotted like this ❧ with ink or some similar dark colour.

A *gongbi* painting must be executed with care and precision. The structure of the leaves and flowers, the joining of the leafstalks with the main stem, the root of the plant – all must be delineated clearly by means of double lines. Since petals are softer and more tender than leaves, use thin ink for the former and heavy ink for the latter. Likewise, use thin ink for the brighter parts of flowers and heavy ink for the darker parts. This increases the three-dimensional effect and makes it easier to apply colour.

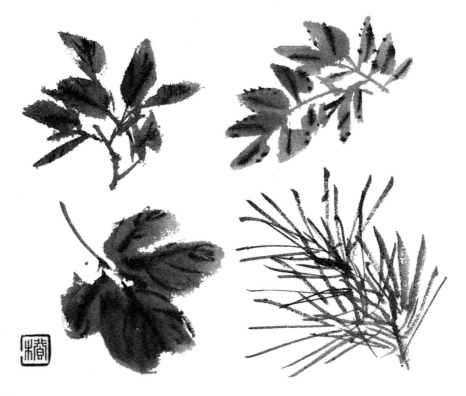

FIG. 171

When you colour a *gongbi* painting, use two brushes, one dipped in the required colour, the other in clear water. As soon as you have coloured a leaf or flower, go over it with water to give it a smooth, even appearance and to remove traces of the brush, but be careful not to grease or soil your work.

The front of a leaf should be painted darker than the back. You can leave a narrow white strip alongside the principal vein, to be filled in with some light colour later. Or, you can do a line in mineral green alongside this

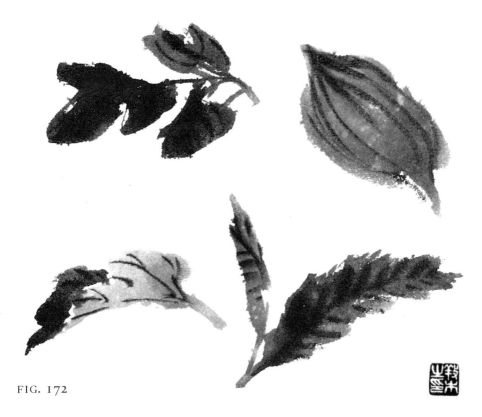

FIG. 172

vein. Both the *fei se* (flying colours) and *zhao se* (undercoating with alum) can be used when colouring leaves and flowers (*see* p.24). FIGS 171–5 are examples of *xieyi* leaves in ink only. FIGS 176–8 are line drawings or double line drawings of leaves and flowers. FIGS 179 and 180 (p.137) are *xieyi* leaves and flowers with colours added whereas FIG. 181 (p.138) shows leaves and flowers with double lines and colours in the *gongbi* style.

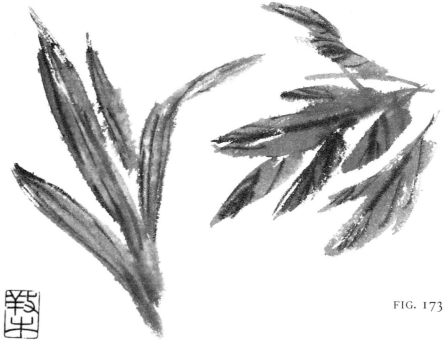

FIG. 173

133

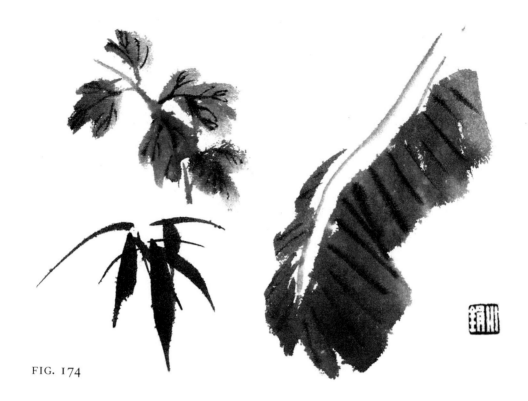

FIG. 174

FIG. 175

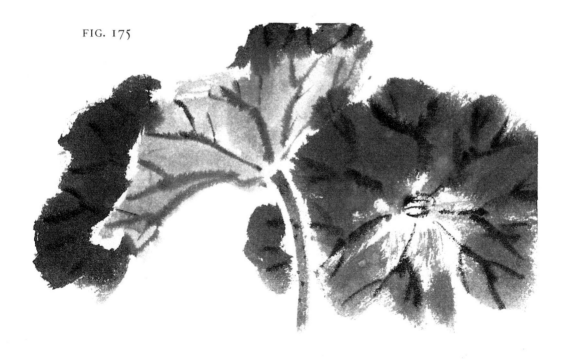

FIG. 176

FIG. 177

FIG. 178

TRUNKS, BRANCHES, VINES AND GRASS

When painting tree trunks in the *xieyi* way, just show the texture and create a three-dimensional effect. A patterned trunk is shown on the left in FIG. 182; a cypress trunk is on the right. FIG. 183 shows the tung tree (left) and pine (right). FIG. 184 is of a willow (left) and (right) a tree of the genus *Prunus* (plum, peach, apricot); and FIG. 185 shows another way of doing a willow.

FIG. 182

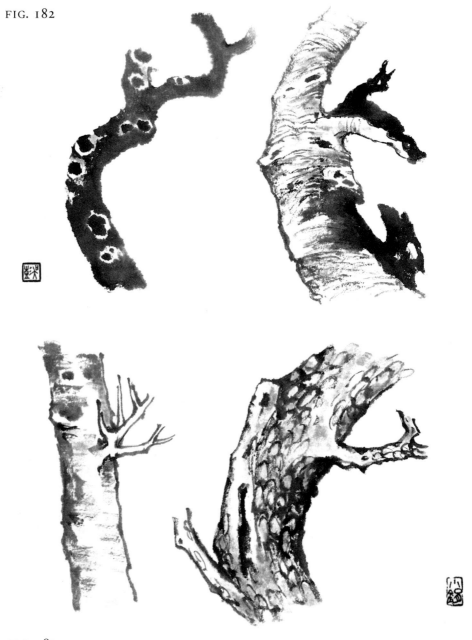

FIG. 183

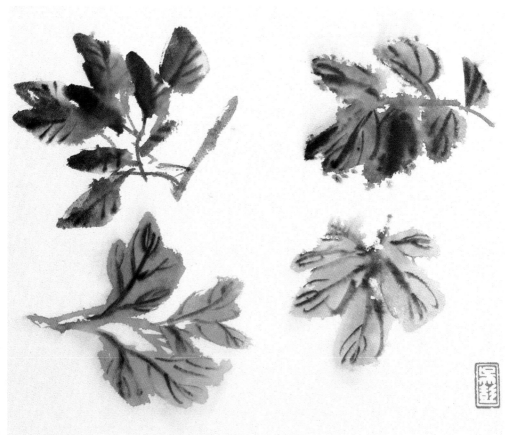

FIG. 179

FIG. 180

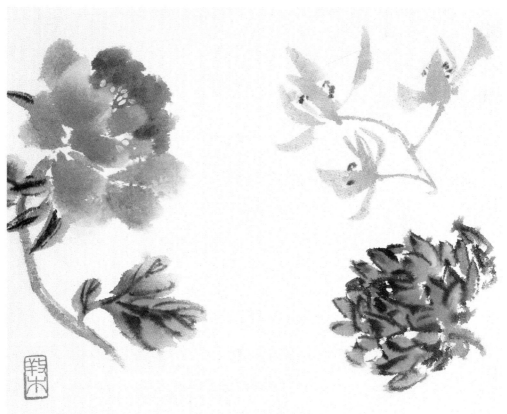

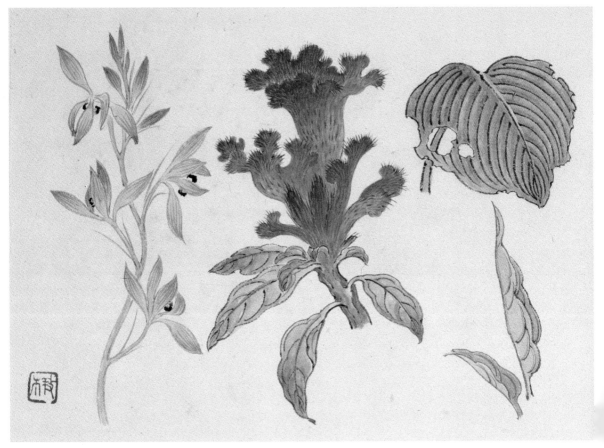

FIG. 181 FIG. 186

FIG. 184

FIG. 186 contains examples of a method of painting called *ji shui* (accumulation of water) that is similar to watercolour painting. It is done on sized *xuan* paper. Apply a background colour to the trunk with a wet brush; then, before it has dried, dot or dab parts of it with mineral green or some other powdered pigment. You can paint the trunks of the crabapple, cherry and pomegranate in this way.

FIG. 185

FIG. 187

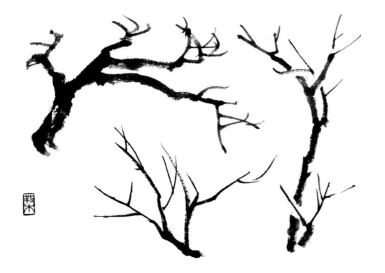

FIG. 188

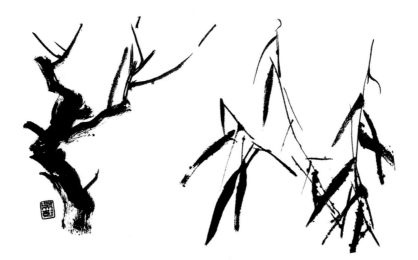

FIG. 189

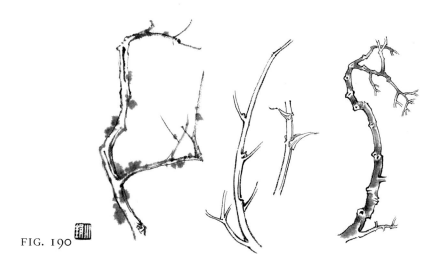

FIG. 190

The tree trunks in a *gongbi* flower painting can be slightly thinner than those in a *xieyi* painting. They can branch out to left or right, up or down. There should be variation in the form and arrangement of the branches, e.g. forked or interlocking, closely packed or widely spaced. They should not be rigid or patterned. FIGS 187, 188 and 189 (left) are examples of how to paint branches. Leave enough space for adding flowers and leaves but the flowers can be painted first on certain woody plants.

Branches in the *gongbi* style should give a clear three-dimensional effect and be executed with double lines. The illustration on the far left in FIG. 190 shows branches executed with double lines and moss dots. The branch on the far right in FIG. 191 was executed meticulously with a dry brush and then textured.

FIG. 191

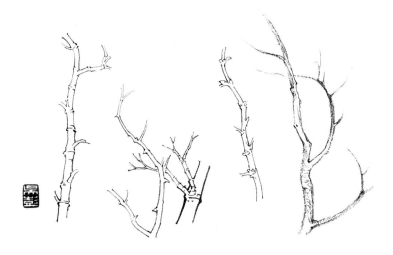

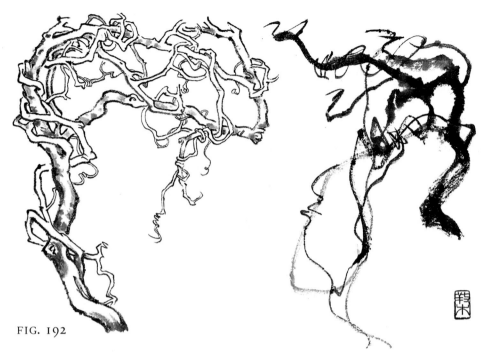

FIG. 192

Vines and grasses should also be painted with a distinct shape. In a *xieyi* painting, they should look impressive but should not be roughly done. The illustration on the right in FIG. 192 is a *xieyi* vine; on the left is a wisteria executed with double lines. In FIG. 193, the grasses on the left were drawn with double lines and those on the right have blades done with single strokes.

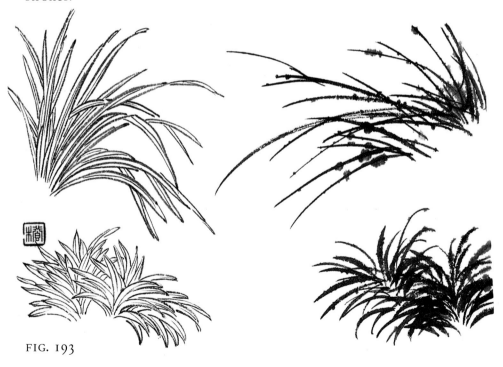

FIG. 193

ROCKS

The rocks in a flower-and-bird painting should be interesting objects in themselves. They are usually called *hu shi* (lake rocks) because they are like the rocks found on the shores of Tai Lake. Examples of porous rocks like those from the lake, and from Kunshan Mountain, are shown in FIGS 197–9.

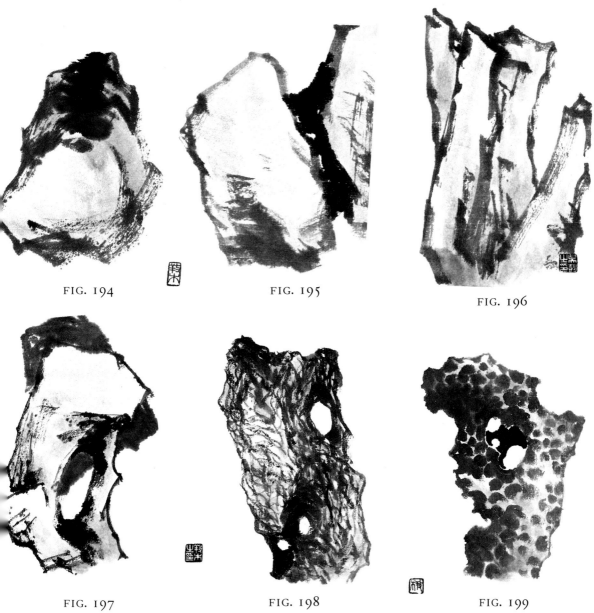

FIG. 194 FIG. 195

FIG. 196

FIG. 197 FIG. 198 FIG. 199

The same textures are also often seen in landscape paintings. Yellow-coloured stone can also look nice in a flower-and-bird painting and the rocks in FIGS 194–6 will create an airy feeling in a *xieyi* painting.

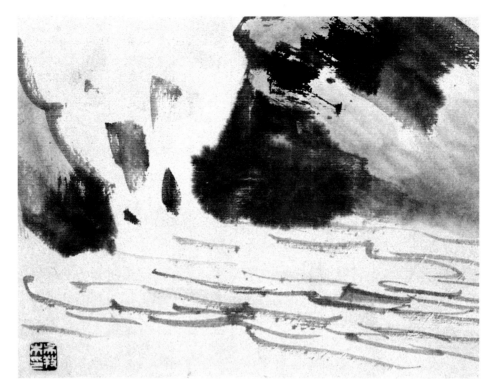

FIG. 200

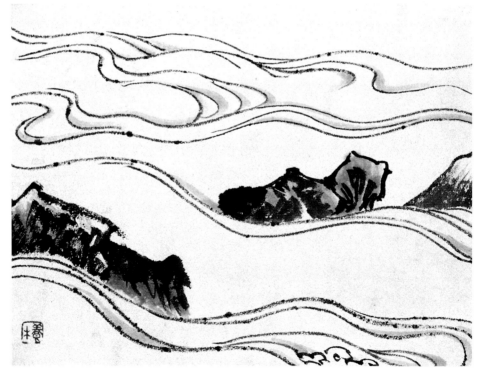

FIG. 201

FLOWING WATER

Generally speaking, flowing water does not occupy an important place in a flower-and-bird painting. In *xieyi* paintings, it is represented by just a few wavelike lines, as in FIG. 200. But in *gongbi* paintings, waves, bends and occasional sprays must all be depicted realistically. Concentration is necessary to do this well. In a large painting, lines that represent water should vary in thickness and in some places appear to be quivering. Some examples of flowing water in a small or medium-sized painting are given in FIG. 201.

GRASS AND INSECTS

Grass and insects are embellishments in a flower-and-bird painting. A single butterfly or dragonfly in the right place can make a big difference to the appearance of a painting. The following lines by Yang Wanli of the Song dynasty are descriptions of paintings with these charming little additions:

> The little lotus has barely shown its tip,
> When a dragonfly swiftly alights upon it.

> The little boy hotly chases a yellow butterfly,
> Which flies into a cauliflower and is lost to view.

The long-horned beetle in FIG. 202 is painted with gluey ink. The segments of its horns were executed with vigorous, clear-cut strokes, and a few spots of white were added on its wings. In the upper right is a frog in ink; this creature must look lively, not like a sullen toad. In the lower part of the picture are a moth (centre) and a bee (left), the latter painted with sturdy legs and thin transparent wings dotted with white. FIG. 203 is of various species of butterfly, one (top right) painted with ink lines and washes, the others with ink dots and colours. The colours should be moderate and the ink should not seep too much. In the upper part of FIG. 204 are three mantises, portrayed with forelegs that resemble knives and triangular heads raised as if looking about. In the lower part of the picture are long-horned grasshoppers done only in colour. Dragonflies, grasshoppers and cicadas, in ink and colour, are shown in FIG. 205.

Grass and insects must look light and lively, not heavy and clumsy. They can be outlined in thin ink and then coloured. A strong colour may obscure the outlines, which is permissible.

FIG. 202

FIG. 203

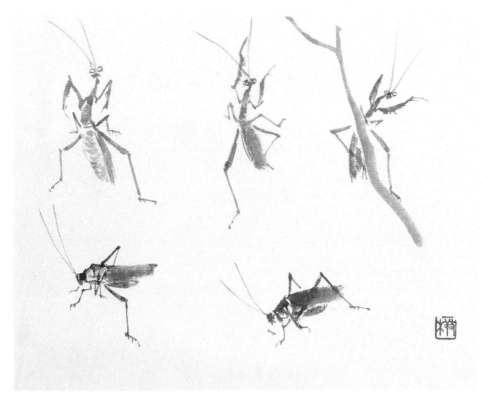

FIG. 204

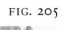

FIG. 205

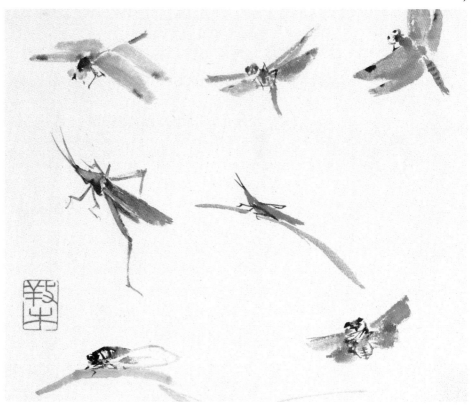

'Gongbi' flower-and-bird paintings in light colours

These paintings are similar to line drawings except for the addition of light colours. If a painting looks a bit flat after one coating of colours, you can touch it up with a second coat, but do not on any account add a third one. The colours must not be brilliant but soft, light and quiet, as shown in FIG. 206. The basket, flowers and leaves are all in subdued colours. The autumn gourd in the foreground was painted with large washes of diluted cinnabar. The white spots represent marks on the fruit.

Not many artists paint in this way, for great care is required in the choice of colours. In a way it is like painting women: a woman with heavy make-up is often easier to paint than one who is unmade-up.

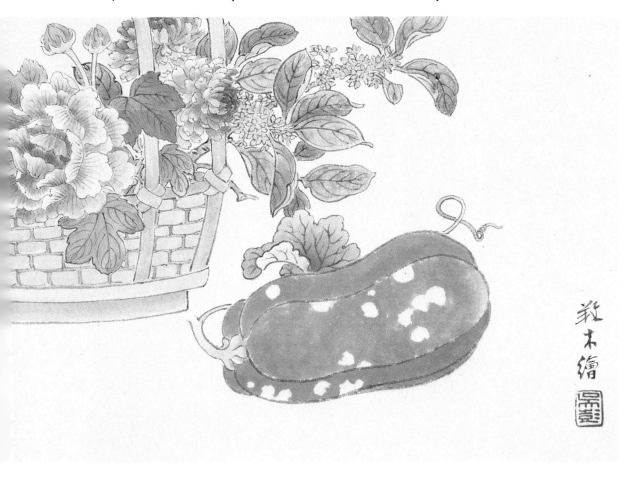

FIG. 206

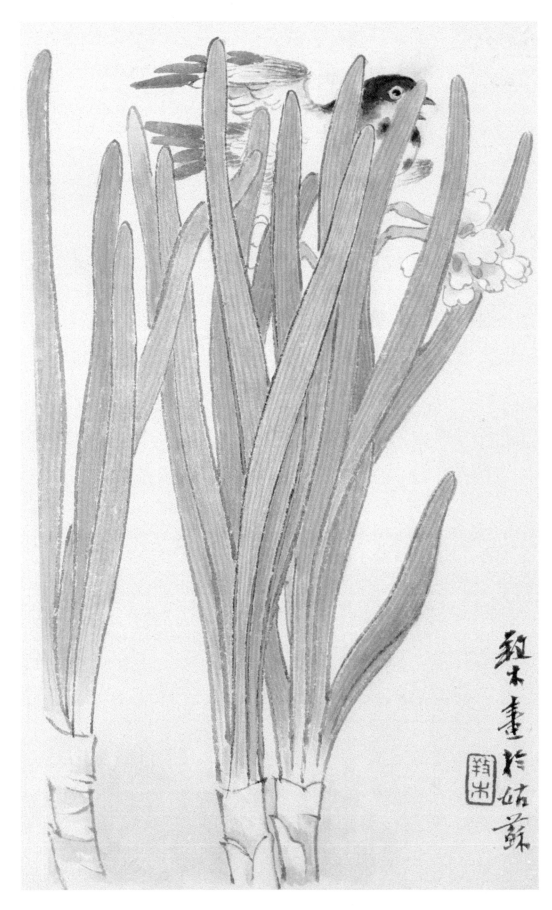

FIG. 2

'GONGBI' FLOWER-AND-BIRD PAINTINGS IN STRONG COLOURS
Double lines and filled-in colours are the principal characteristics of such
paintings. To 'fill-in' here means to enrich the colours. Such methods as *tuo
di* (coating the back), *pu di* (priming), *zhao se* (undercoating with alum) and
fei se (flying colours) may all be used (*see* p.24), but with care.

1. When you paint a flower in dark colours, a rose or purple peony for
example, apply a layer of thin ink as base on the small space between
adjacent petals; then add colour, layer by layer, to the petals, including the
inked space. Do not add too many layers as it might result in too much
water, which would cause the colour to run and accumulate on one side.
Because of this, when colouring, you must paint a whole petal from base to
tip in one go. The base of a petal, i.e. the part nearest to the heart of the
flower, should be darker than the tip. There are, however, exceptions in
which the tip is darker, as in the orchid shown on the left in FIG. 181 (p.138).
After several layers have been applied, some strong colours may look thick,
but they will not look greasy. They will have a smooth, even appearance like
a picture in monochrome, but different in tone. When painting a brightly
coloured flower, you can use three brushes, one loaded with clear water, the
other two each with a different shade, one for the petal tips, the other for the
base.
2. In general, when you are colouring a leaf, you should also apply a base
layer of ink, but this is unnecessary if it is a tender leaf. The colour can be
thickened by adding more layers.
3. When you are painting a bird, it is only necessary to delineate its bill and
eyes and some of its coverts and flight feathers. The primaries must be
delineated clearly, but there is no need to outline each and every feather on
the belly, back, head, throat and breast; you only need to colour these parts.
The quills of large feathers such as the tail feathers and primaries may be
delineated too. You can leave small breaks in the lines of the feathers to
represent minor defects in them.

If it is a very large bird, the scale-like skin on its toes should also be
depicted. FIG. 207, *Narcissus and Wild Bird*, is an example of a simple *gongbi*
flower-and-bird painting in strong colours.

THE DIFFERENT PARTS OF A BIRD

Birds are often referred to as 'feathers' in traditional Chinese painting. While a painting can contain only flowers, one or more 'feathers' perched on a branch or in flight will give more life to the picture.

To learn how to paint a bird, you must be familiar with the different parts of its body. These are shown in FIG. 208.

1. bill 2. upper mandible 3. lower mandible 4. gape 5. nostril 6. forehead 7. head 8. crown 9. nape 10. ear coverts 11. hindneck 12. side of neck 13. mantle 14. scapulars 15. back 16. tertials 17. rump 18. upper-tail coverts 19. chin 20. throat 21. breast 22. shoulder 23. lesser coverts 24. median coverts 25. alula 26. flank 27. greater primary coverts 28. belly 29. thigh 30. toe 31. greater coverts 32. primaries 33. under-tail coverts 34. tail feathers 35. tarsus

Bird movements are hard to capture on paper. A traditional method is to draw two ovals, a small one for the head and a large one for the body, variously positioned in relation to each other. Then add the bills, wings, tail, toes, etc. to create the numerous postures and movements of a bird (*see* FIGS 209–13).

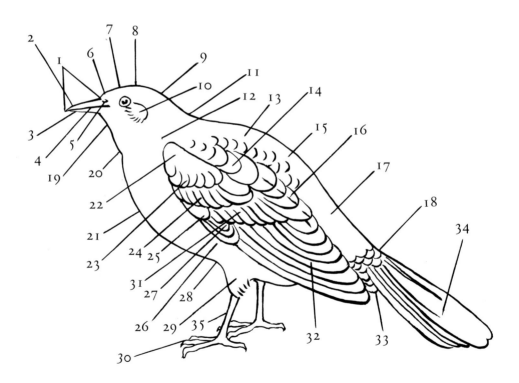

FIG. 208

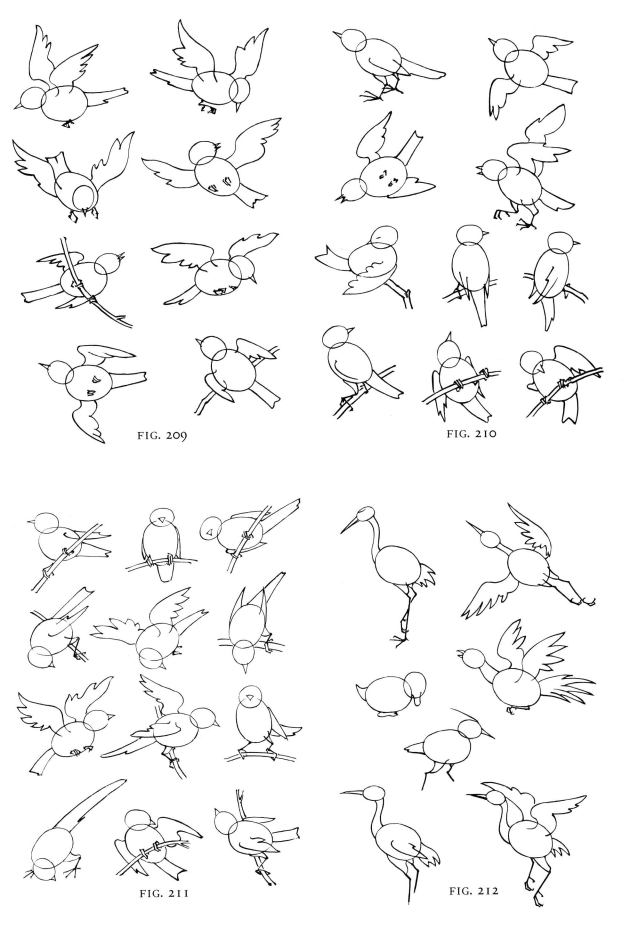

FIG. 209

FIG. 210

FIG. 211

FIG. 212

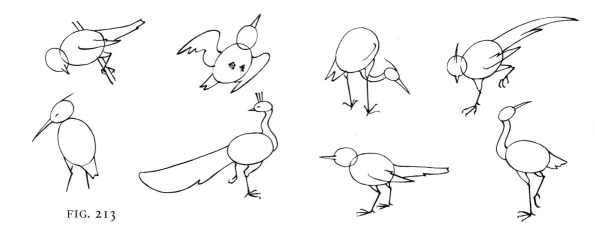

FIG. 213

LINE DRAWINGS OF FLOWERS AND BIRDS

These drawings are usually done with double lines and thin ink, and work well without any colouring or embellishments, but should be viewed at close quarters. They have a subtle elegance and an aura of solemnity. There are two ways of doing them:

1. Make a draft and then trace out the drawing on sized *xuan* paper using a rabbit or wolf brush with a pointed tip, or a brush with a short tuft called a 'small crab claw', or one for doing the veins of leaves. The brush should be stiff and the ink thin, in fact so thin that a person with poor eyesight would hardly see the lines. Start each stroke from the tip of a petal or leaf, or from the leafstalk, making a slight pause for accentuation at the beginning of the stroke. Add the veins of the leaf last. Retracing a line is permissible when you are drawing a bird, especially the feathers, whose lines should be properly grouped but should not be parallel.

2. Use orchid-leaf or willow-leaf tracing, which is often used to do the folds of a woman's garment in a *gongbi* painting. (These are two of the eighteen traditional techniques of delineating folds in clothes and are named after the shapes that are created.)

FLOWER-AND-BIRD PAINTINGS WITH MINIMAL STROKES

Before doing a painting of this kind, you must have the theme clearly in your mind, in order to create a good composition. After you start painting, you may find it turns out differently from your original conception. If so, there is no harm in making last-minute changes to the shape and position of your subjects. To capture the essence of a subject with just a few strokes is a skill that comes from practice. To achieve perfection, one must use the same method or technique again and again; at the same time, one must guard

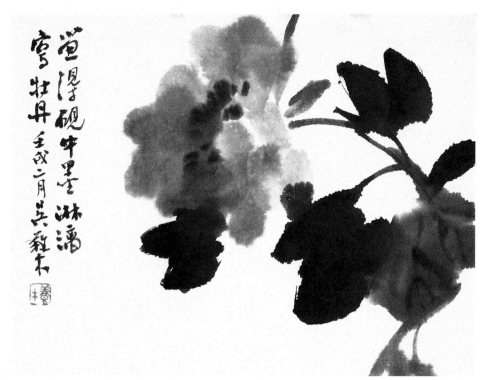

against triteness and conventionality. After long practice, you may quite
unexpectedly find that you are able to 'wield the brush with magical effects'.
FIGS 214–19 are examples of paintings done with just a few strokes; they are
scenes common in Chinese gardens or the countryside.

IG. 215

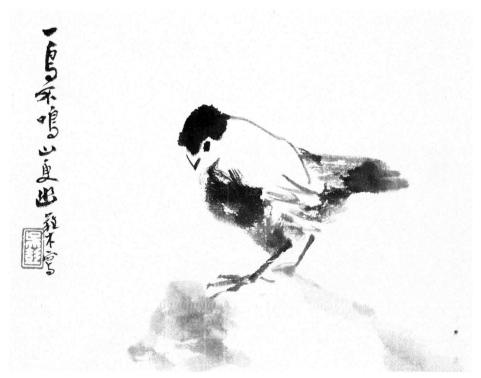

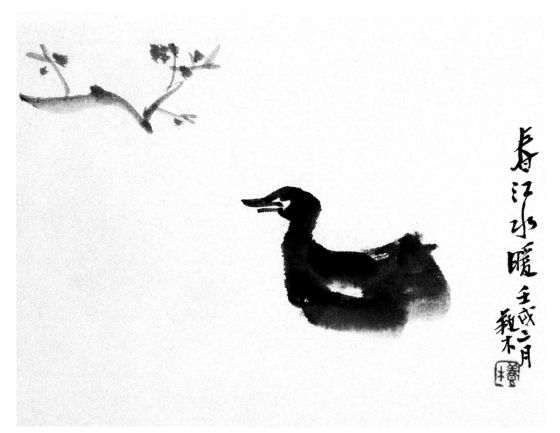

FIG. 216

FIG. 217

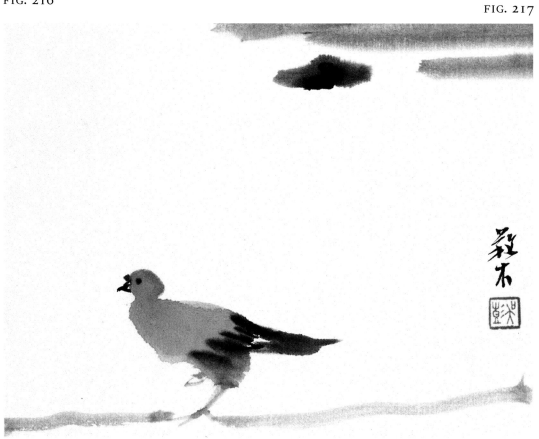

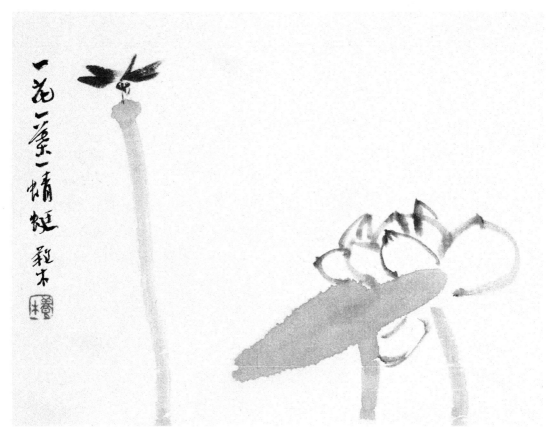

FIG. 218

FIG. 219

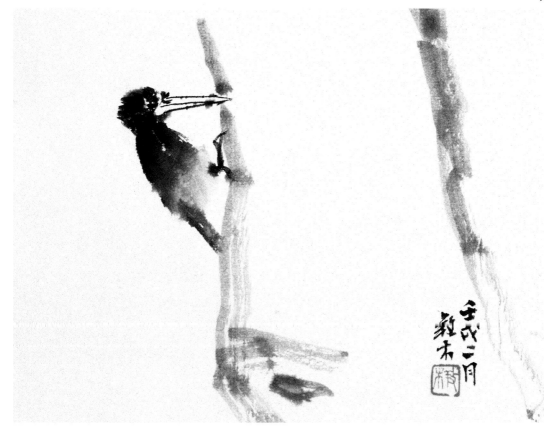

'Xieyi' flowers and birds

Begin with simple paintings.

FIG. 220 is a painting of an eagle on a pine tree. The pine needles are a combination of thick and thin strokes. The eagle, which is only half exposed, is in thin ink.

The peacock's head, neck and back in FIG. 221 are in gluey ink and its tail in thin ink.

FIG. 222 is a narcissus in ink with some outlined flowers inserted between the leaves. It is an example of the contrast between black and white and thick and thin strokes.

FIG. 223 is a painting in simple brushwork of the autumn willow and a cicada.

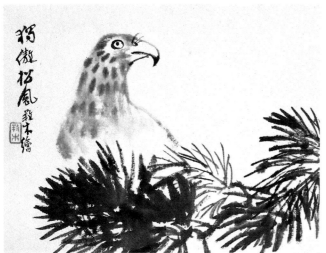

FIG. 220

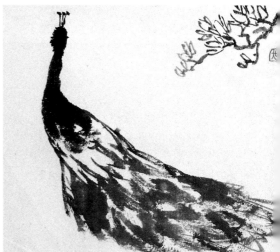

FIG. 221

FIG. 224 is of peach blossoms and a small bird. The head of the bird was painted first, with gluey ink; the breast and tail were brushed in with sweeping horizontal strokes.

The flowers of the rose in FIG. 225 were painted first and the butterfly was added in ink as an ornament. Here the leaves look better in reddish brown than in green.

FIG. 226 is a painting of bright red flowers, and leaves without veins showing. The rock in ink was added for contrast.

Xieyi painting includes the splashed-ink technique and the so-called *da* (great) *xieyi* which permits even greater freedom of brushwork and less attention to the forms and details of objects. In *xieyi* painting, the usual order is to do the flowers, then the leaves, and lastly the stalks. In the case of woody plants, do the trunks and branches, then the leaves and flowers.

FIG. 222

FIG. 223

FIG. 224

FIG. 225

IG. 226

FIG. 227

'Meigu' (boneless) flowers and birds

The most important feature of *meigu* flower-and-bird paintings is that ink is replaced by colours. The fringed iris, depicted in FIG. 228, has leaves and flowers in the same colour tones, yet they are clearly distinguishable from each other. The canna in FIG. 229 was done with a dry brush; the leaves are

FIG. 228

FIG. 229

noticeably dry but the flowers are slightly moist. Only the eyes and bill of the bird in FIG. 230 have been dotted in ink, so it may still be considered a *meigu* painting. FIG. 231 may also be classified as a *meigu*, although the leaves and flowers are in ink and umber.

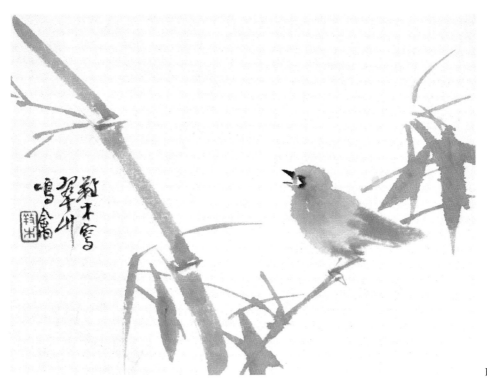

FIG. 230

FIG. 231

Flowers and birds in 'gongbi' and 'xieyi' styles

In these paintings, only the birds are meticulously executed in the *gongbi* style; everything else is done in the *xieyi* manner.

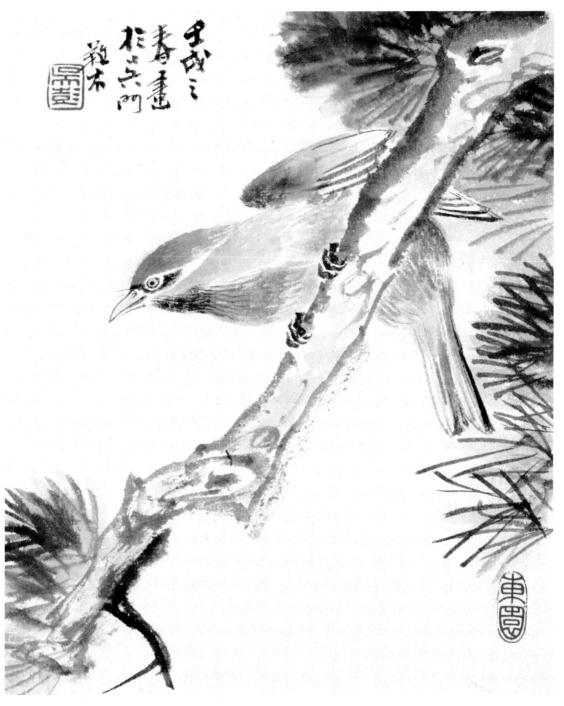

FIG. 232

DECORATIVE FLOWERS AND BIRDS

Flowers and birds painted with double lines possess a strong decorative quality. This quality is enhanced when artistic exaggeration is used. Therefore, the images in decorative paintings, irrespective of whether they are flowers, birds, rocks or branches, must be appropriately exaggerated or distorted in shape. In FIG. 233, the shape of the crane has been altered; the pine branches extending horizontally resemble dragons and snakes; and the pine needles are depicted in clusters that resemble balls. The body of the crane is shown up by colour contrast, and a number of gem-like dots have been placed on the branches as embellishments.

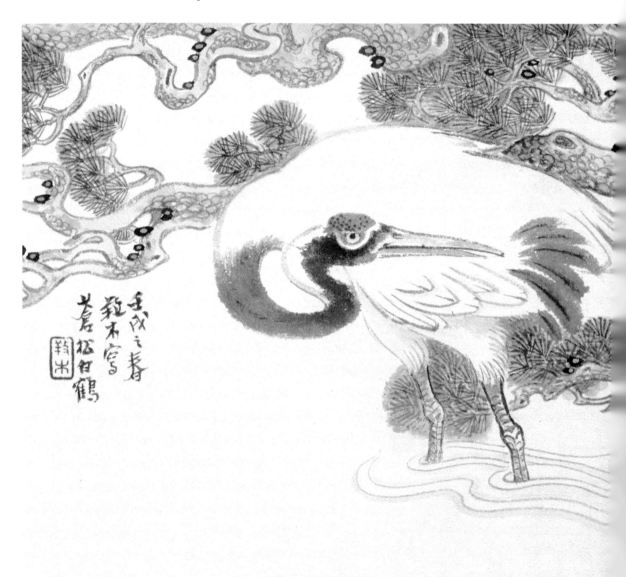

FIG. 233

How to paint the plum, orchid, bamboo, chrysanthemum and pine

There are traditional ways of doing each of these subjects. Distinctive styles have emerged in different historical periods. Some artists concentrate on just one or two of them.

Plum: The plum blossoms early in the spring. When painting a plum tree do the trunk and large branches first. The branches of a plum tree extend sideways; some are straight, some crooked. They can be painted with single or double lines, with a dry brush or a brush dripping wet. Moss dots may be added to give a downy appearance. In some places, only a few such dots are needed; in others, they may be arranged densely in series.

Do the flowers next, together with the small branches and twigs. Blossom should appear only on the small branches and twigs. Some artists portray plum blossoms as small circles; some use thin ink dots; some paint them vermilion or green. Blossom depicted in these different ways is called white plum, ink plum, red plum and green plum respectively. Sometimes a variety of colours are used – umber, greenish red, purple and even indigo – and the result is called a variegated plum. Yellow is not used because it might cause confusion with the wintersweet.

Blossom should be depicted at various angles: facing upwards, downwards, towards the front or the back; and at different stages of growth – in bud, half open, fully open. It may be painted densely or sparsely according to preference.

Now add the buds and calyces. When you paint the calyx of a flower, do not place the sepals too close together. If you are portraying the front view of a flower, you can just put a dot on each side as a sepal and one in the middle, a little longer, as the stalk (see the top right blossom in FIG. 234). If it is only a bud, put three or four dots around it at an equal distance from each other. A plum blossom is usually portrayed with five united petals and stamens of varying density. The stamens should be straight, not curved. Finally, dot the pollen. When you dot pollen on the stamens in the *gongbi* style, do not space your dots too regularly as if in a circle. The paint should be thickly applied so that the dots will stand out, even when dry. When painting in the *xieyi* style, you can add the pollen with ink or with a dark colour.

FIG. 234 is a painting of a plum in the Ming style and FIG. 235 is of a red plum.

Orchid: This is a herbaceous plant of which people say: 'A bowl of orchids in a room fills the air with fragrance.' There are different ways of depicting orchids: with double lines and colour; as line drawings; or with single lines and ink and wash. Each has its special features.

The most important part of an orchid painting is the leaves. Each leaf

FIG. 234

should be completed in one stroke, starting from the base; there must be no retracing, only retouching along the sides where necessary. This is what makes painting orchids so difficult. The leaves should crisscross each other naturally and should vary in thickness, a leaf facing the front being thicker than one represented in profile. They should also vary in density, but there should not be too much light/dark contrast. A young leaf may be depicted like a blade of grass. Orchid blossoms should appear behind the leaves, not in front of them. The shape of an orchid blossom varies, but as a rule there are five petals. Stamens are done in black ink. In FIG. 236 the leaves are thickly painted whereas in FIG. 237 the leaves are thin, the blossoms light, and the stamens dark.

Bamboo: Before painting bamboo you must have a good idea of what the plant is like. Then, with the right conception, a few strokes can produce a good painting. A good way to study the shape and posture of bamboo is to observe its shadow cast upon a white wall by moonlight or lamplight. Long, patient observations like this are very helpful.

There are numerous varieties of this plant and the main difference is in the leaves. Painting bamboo leaves is sometimes called 'cleaving' because the strokes should be short and quick as when using a cleaver. To paint bamboo properly, one must know not only the structure of the plant but also

FIG. 235

FIG. 236

FIG. 237

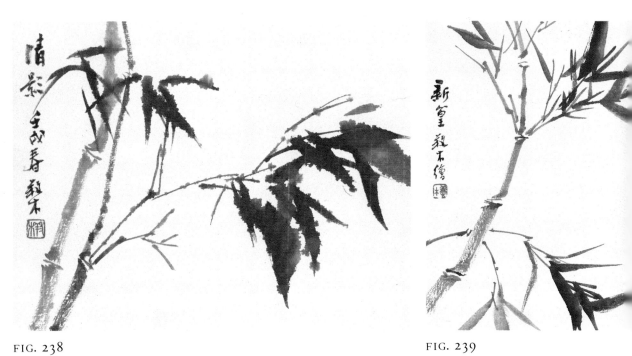

FIG. 238

FIG. 239

how to paint the leaves and do the stems (culms). A thick stem should be painted from bottom to top with the brush held almost horizontally. The brush should be loaded with ink of different consistencies so that the light and dark parts of the stem, representing light and shade, may be produced in one stroke. The joints on the stem should be delineated in thick ink with thin, straight horizontal lines added while the stem is still wet. If it is a thin stem, the joints can be done in thick or gluey ink and may be shaped thus: '⌣'. Fine branches, which grow out of the stem at the joints, should be depicted in different ways: singly, in pairs, and in clusters.

The leaves are usually shaped like the character '介' or '个', and they must vary in density. Quite a few artists put the stress at the beginning of a stroke when painting the leaves. I give more weight to the stroke in the middle of a leaf to make the leaves appear more supple and less sharply defined. There should be some strokes that cross each other, and one or two sweeping strokes that extend outwards. In the dense parts of a *xieyi* painting, the ink should be allowed to seep and diffuse; not every stroke has to be clear and distinct. Some leaves, however, should be painted distinctly, such as those in the sparser parts of the painting; in fact, on a very slender twig, it may suffice just to paint one solitary leaf. You might refer to *The Mustard Seed Garden Manual of Painting* of 1679–1701 (Princeton University Press, 1977) for ways of painting bamboo leaves: 'Leaves that extend upwards can be painted in one stroke like the side of a boat; in two strokes like a fish tail; in three strokes like a wild goose in flight . . . Leaves that hang down can be

painted in one stroke like a feather; in two strokes like a swallow's tail; in three strokes like the character '个'; in four strokes like the tail of a wild goose that has alighted. They can also be shaped like the character '分', overlapping each other. When I paint bamboo, I usually do the leaves first and then the stem, and join them with thin branches.

In FIG. 238 the leaves hang down; in FIG. 239 they extend up or out like the leaves of the so-called 'sky-facing bamboo'. In general only two colours are used when painting bamboo: indigo and watery green. Some artists use cinnabar, and a bamboo painted in this colour, called a 'cinnabar bamboo', has an unusual charm.

Chrysanthemum: people love the chrysanthemum because it flowers in autumn and has a hardy nature; it can withstand cold and frost. There are numerous varieties. On paper, it is depicted in more or less the same way as other flowers, usually with a background of rocks, slopes, hedges, grass and brambles. FIG. 240 is a painting of chrysanthemums in ink, and FIG. 241 shows them in colour. In the latter, the petals were outlined first and the leaves added later, a method called 'outlining the flowers and dotting the leaves'. Red dots were added on the petals to enhance the beauty of the

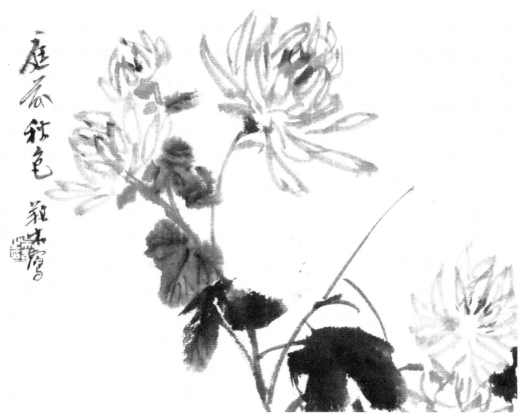

FIG. 240

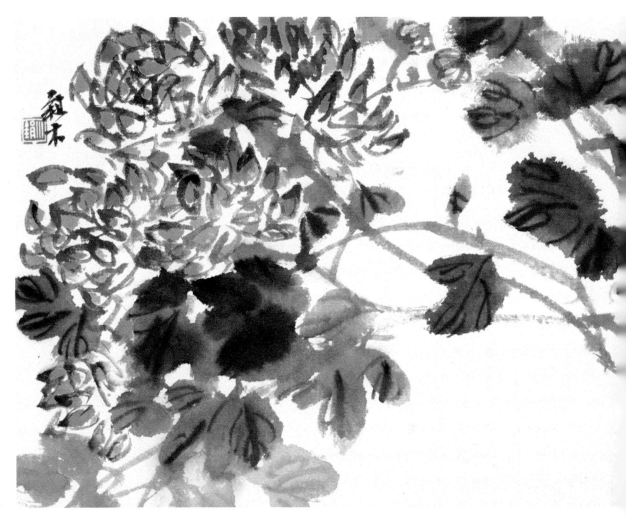

FIG. 241

flowers. However, the modern artist Wu Changshuo did chrysanthemums the other way round. He coloured the petals first, then added the outlines in gluey ink while the colours were still wet. The mutual seepage of ink and colour was one of his special techniques.

Pine: The pine has an upright trunk and straight horizontal branches, though the trunks of some varieties are bent or crooked. The trunk of a pine can be depicted with a dragon-scale texture (*see* p.41), which should be distributed unevenly over the surface to create an effect of light and shade. Knots should be added to create a feeling of age. Pine needles have a tendency to grow upwards from the branch. Some artists paint the needles with a large brush; others use a small, pointed one but they produce equally good results. FIG. 242 is of a pine done in ink; FIG. 243 is of a pine with double outlines, to which touches of indigo and umber have been added.

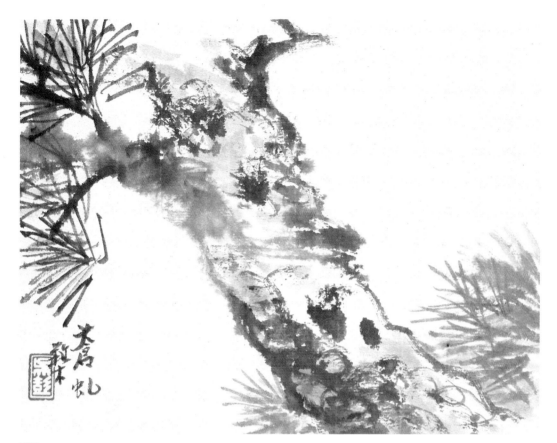

FIG. 242

FIG. 243

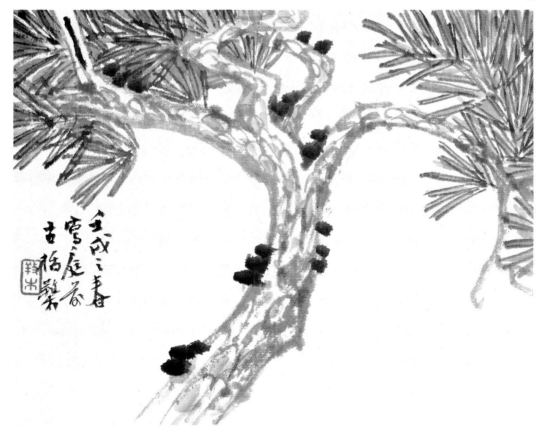

Fruit and vegetables

When you have learnt the techniques of flower painting, you will not find it hard to paint fruit and vegetables, for the rules and methods of contouring and dotting them are the same. The pineapple in FIG. 244 was painted according to Wu Changshuo's method of doing the chrysanthemum, in which he used colours first and added ink later. When you do the contours of lotus roots as in FIG. 245, be careful how you space the openings. The lemons in FIG. 246 have a dragon-scale texture like that on the trunk of a pine, but it is more delicate than the pine texture. FIGS 247–9 are the same as flower paintings; where fine workmanship is required, the rules and techniques of *gongbi* flower painting may be used.

FIG. 244

FIG. 245

FIG. 246

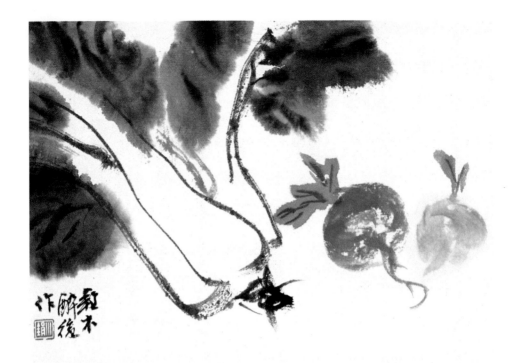

FIG. 247

FIG. 248

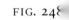

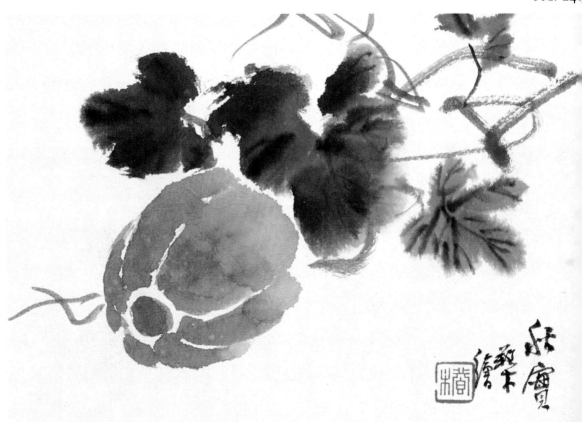

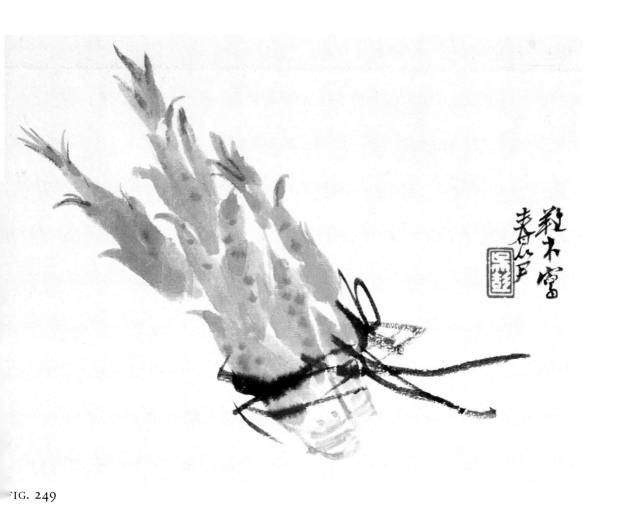

FIG. 249

ANTIQUES: VASES, BOWLS, CUPS, TEAPOTS, JARS, BRUSH RACKS

A flower painting often includes a couple of antiques as ornaments, such as the vases, bowls and brush racks that artists like to keep on their desks. There is not much variation in the way such objects are depicted. A general rule is that the brushwork should be vigorous and the ink thin. Racks and stands, however, look better in thick ink. As a general rule, an ornamental object should be painted in darker colours at the top and lighter ones at the bottom. Cracks may be added on some porcelain articles. Glass vessels can also be included in a flower painting. FIGS 250 and 251 are ink paintings, with no colours, of a cup and teapot, and jar of purple sandstone. These were textured carefully with traditional techniques to show light and shade and the roughness of the surfaces. The base of the vase in FIG. 252 has been left to the imagination. Depicting something at close range in this way is not very common. FIG. 253 consists of a dish of coloured pebbles and a jar of magnolia yulan. Half of the surface of the jar has been lightly coloured to create a three-dimensional effect.

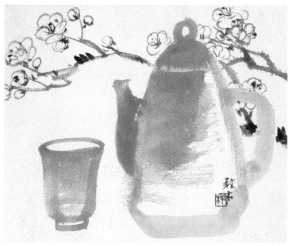

FIG. 250

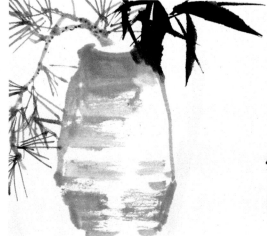

FIG. 251

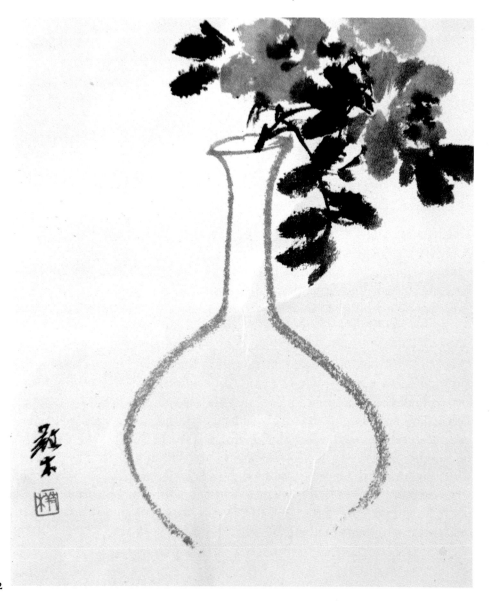

FIG. 252

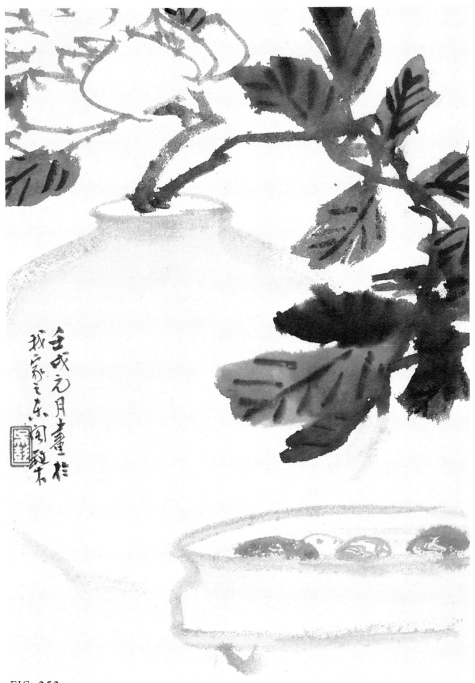

FIG. 253

COMPOSITION AND GENERAL APPEARANCE OF A PAINTING

In appearance, the composition of a flower painting differs from that of a
landscape, but the principles and rules are similar. Shown here are twelve
ways of composing flower paintings, based on the twelve subtypes of
landscape composition (*see* p.113).

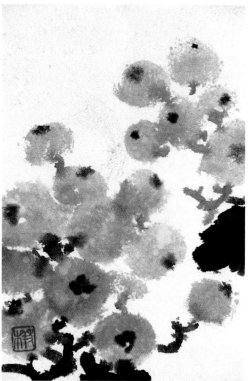

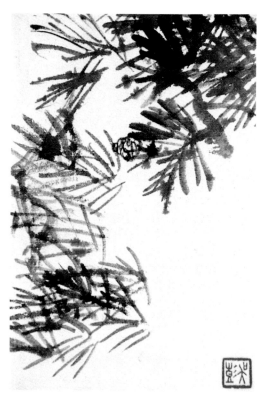

1. Only the upper part of the subject is shown.

2. Only the lower part of the subject is shown.

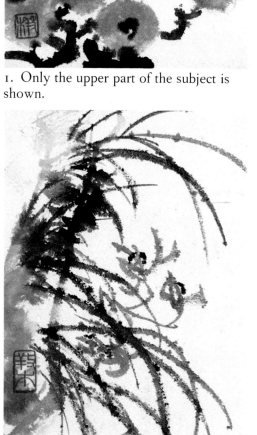

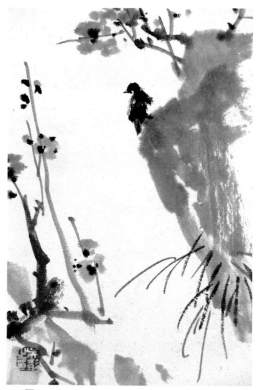

3. One side or aspect of the subject is stressed.

4. The subjects are mostly at the two sides; the middle is almost empty.

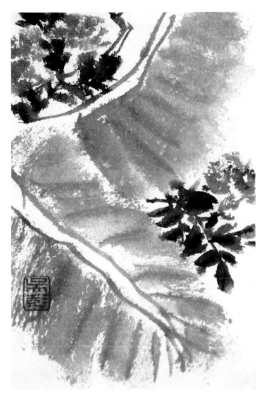

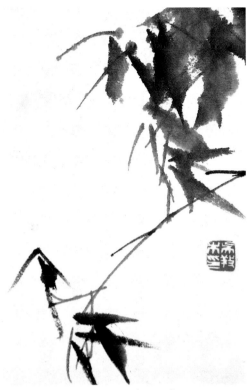

5. All parts of the painting are filled.

6. The subject is mostly in the upper part of the painting.

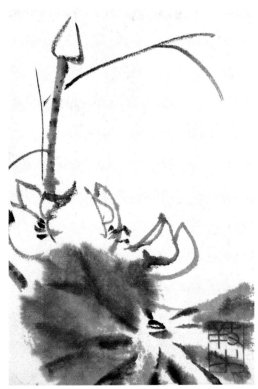

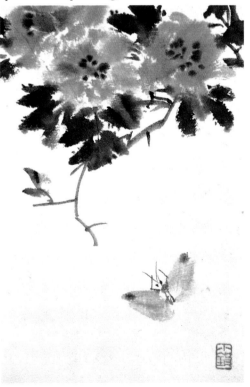

7. The subject is predominantly in the lower part of the painting.

8. The subject is mostly in the upper part of the painting.

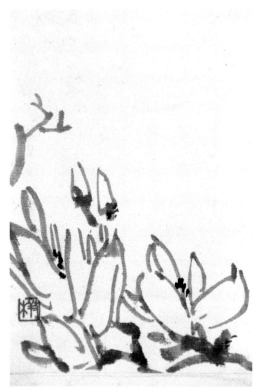

9. The subject is almost entirely in the lower part of the painting.

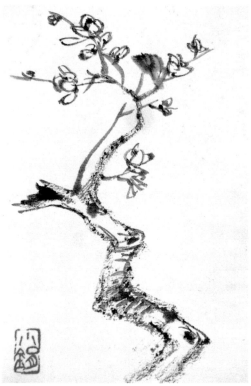

10. The most important subject is in the centre of the painting.

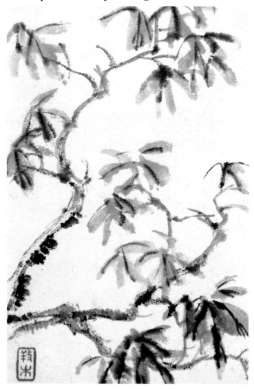

11. The subject appears to be scattered but is not fragmented.

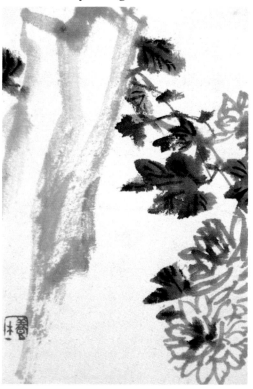

12. The left and right sides of the painting are approximately balanced.

There are not as many compositions in flower-and-bird painting as there are in landscape painting. But since the methods of painting flowers and birds vary a great deal, the same type of composition can actually have two different structures. The most important thing, however, is to master the basic skills. Do not be discouraged by difficulties and failures. For those who do not give up, initial setbacks will lead to ultimate success.

POINTS TO REMEMBER

The points to remember in flower painting are largely the same as those in landscape painting, but the following additional points may also be worth noting:

1. Sketching from nature is very important. Use an HB pencil and make your sketches look like line drawings. Do the flowers and leaves carefully with colour pencils. While sketching, remember to do some pruning as well, that is, discard what is superfluous.

2. Begin your work in the spring, making sketches whenever you see flowers in bloom, and continue until the end of the year. You will then have sketches of all the seasonal flowers. Augment your collection year by year.

3. When painting flowers in the *xieyi* style, stand rather than sit.

4. All creative work must have some traditional basis; there can be no pure creation.

5. Do not paint when you are in a disturbed state.

6. Painting flowers and birds on gold paper is even more difficult than painting blue-green landscapes. The painting must be finished in one go. Going over it too many times may cause the gold to peel off.

7. When painting flowers in the *xieyi* style, hold the brush perpendicular to the paper. Paint resolutely and vigorously, and do not worry about the diffusion of the ink and colours, nor their shades. In this way, you will consciously or unconsciously give more power to your painting without unduly stressing any part of it.

8. Painting a bird is not like drawing a biological specimen. There can be alterations in both form and colour, which is why we have the old saying: 'No one knows the names of these wild birds'. But alterations in form should not be overdone.

9. When painting in the *gongbi* style, do not spread a colour too evenly over a surface; there should be some difference in shade.

10. The composition of a painting must produce a sense of power or force. To achieve this, the left and right sides of the painting must not be fully balanced, still less symmetrical. It is better for one side to dominate, to tilt a little as if bearing down, and for the other side to appear more or less as a counterpoise. Numbers 4 and 12 of the twelve compositions described above are good examples.

11. An inscription often helps to remedy a defect in the composition of a flower painting.

12. *Xieyi* flowers must have a sprightly appearance. Splashed-ink flowers-and-birds must include a few clear-cut strokes.

IMITATION, PAINTING FROM NATURE, CREATIVE WORK

As in landscape painting, the student of flower-and-bird painting can start by making copies of the old masters. Painting from nature and creative work can be done at the same time and the two should complement each other. In landscape painting, there are old and new methods; in flower painting, there is not much difference between the old and the new. Your conceptual ability will increase as a result of painting from nature and creative work.

Here are a few of my works (FIGS 254–7) as examples. FIG. 255 is a painting retouched in colour. Touches of umber have been added on the ink flowers and leaves.

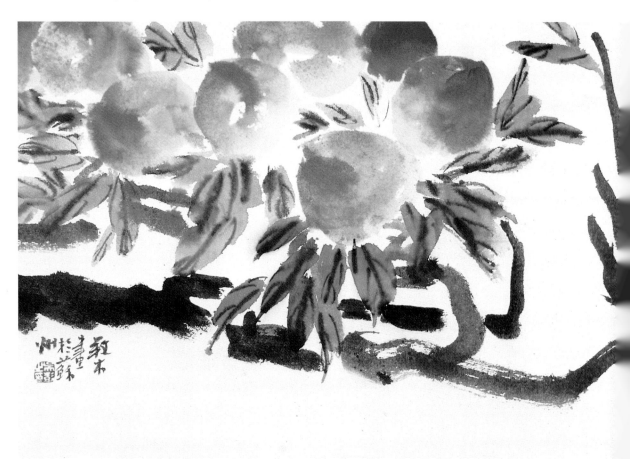

FIG. 254

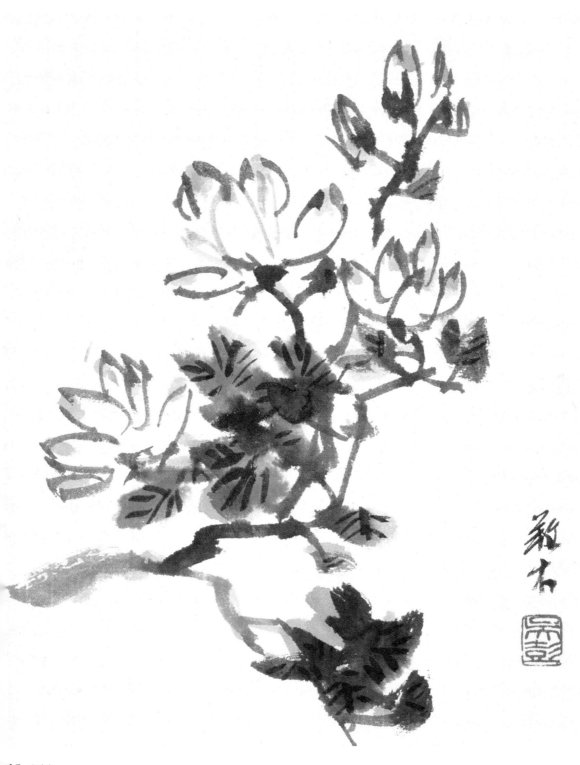

IG. 255

185

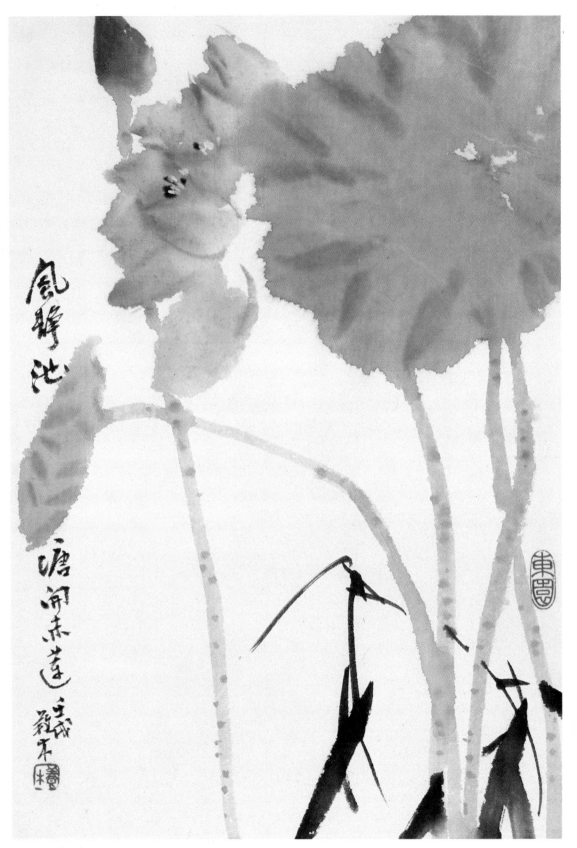

FIG. 256

FIG. 257

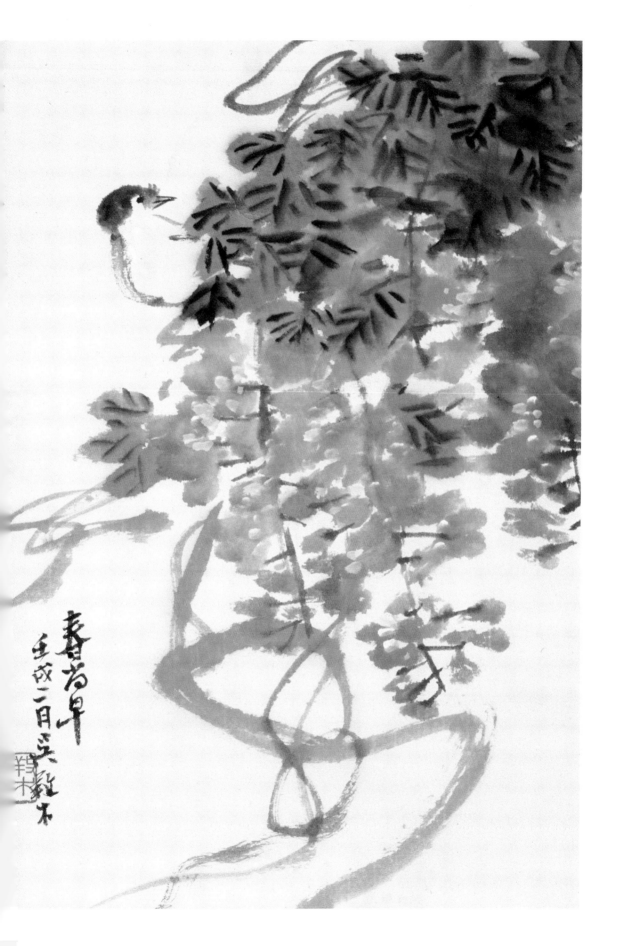

FIG. 258

ANIMALS

When learning to paint animals, you must do plenty of sketches from life or make close observations of your subjects over long periods. Only in this way will you become familiar with their nature, colours and characteristics. Traditionally, animals are hardly ever depicted in outline. Some of the animal paintings we see today are variations of ancient or earlier works; some are paintings from life; and some are paintings from the artist's memory. My painting of a sleeping fox (FIG. 258) belongs to the last category; it was inspired by a visit to a zoo fifteen years ago and the animal's facial features were based on those of a comedian in a Beijing opera. In FIG. 259, which shows a red-faced monkey, the limb that is scratching the back was added later. People have said that this monkey truly possesses a simian spirit.

FIG. 259

Appendix

Selected List of Suppliers

THE DYNASTIES

SHANG *c.*1600–1027 BC

ZHOU (Chou) 1027–256 BC
 Warring States 475–221 BC

HAN 206 BC–AD 220
 Three Kingdoms 220–265
 Six Dynasties 222–589
 Sui 581–618

TANG 618–907
 Five Dynasties and
 Ten Kingdoms 907–960

SONG (Sung) 960–1279
 Northern Song 960–1127
 Southern Song 1127–1279

YUAN (Yüan) 1271–1368

MING 1368–1644

QING (Ch'ing) 1644–1911

The names in brackets are the old Wade-Giles system of transcription which may be more familiar to some readers than the modern pinyin.

*mail order available

HONG KONG

Jub Tai Cheoon*
274 Queens Road C,
Hong Kong

Man Luen Choon*
29–35 Wing Kut Street
Harvest Building
2nd Floor, Flat B
Hong Kong

ENGLAND

Guanghwa Company*
7–9 Newport Place
London WC2H 7JR

F. Hegner & Son
13 South End Road
London NW3 2PT

L. Cornelissen & Son
105 Great Russell Street
London WC1B 3RY

Neal Street East
5–7 Neal Street
Covent Garden
London WC2H 9PU

Philip Poole & Co.
182 Drury Lane
London WC2B 5QL

Typhoon Ltd
64 Long Acre
Covent Garden
London WC2E 9JH

Mitsukiku
4 Pembridge Road
London W11

209 Kensington High Street
London W8

26 North Audley Street
London W1

15 Old Brompton Road
London SW7

90 Regent Street
London W1

435 Strand
London WC2

Unit 47
North Walk
The Pallasades
Birmingham B2

18 Brighton Square
The Lanes
Brighton

Royal Exchange Shopping C
Market Street
Manchester

Wagons Art Supplies
85 High Street
Hemel Hempstead
Herts HP1 3AH

Samarkand Gifts
31–5 Elm Hill
Norwich NR3 1HG

Chinese Art Centre
50 High Street
Oxford OX1 4AS

The Brush & Compass
14 Broad Street
Oxford OX1 3AS

Centre of Restoration & Arts
8 Adelaide Street
St Albans
Herts AL3 5NP

Harberton Art Workshop
27 High Street
Totnes
Devon TQ9 5NP

The Deben Gallery
26 Market Hill
Woodbridge
Suffolk IP12 4LU

USA

Pearl Art & Craft Supplies*
5695 Telegraph Road
Alexandria
VA 22303

Co-op Artists Materials/Atlanta
 Airbrush*
PO Box 53097
Atlanta
GA 30355

Harvard Square Art Centre*
17 Holyoke Street
Cambridge
MA 02138

Utrecht Art and Drafting Center*
332 South Michigan
Chicago
IL 60604

Denver Art Supply*
1437 California Street
Denver
CO 80202

China Art Material and Art Books*
China Cultural Center
970 North Broadway, Suite 210
Los Angeles
CA 90012

Arthur Brown & Brothers*
2 West 46th Street
New York
NY 10036

Unique Artists Supply Co.*
838 Grant Avenue
San Francisco
CA 94108

Daniel Smith Inc.*
4130 First Avenue S.
Seattle
WA 98134

AUSTRALIA

Oxford Art Supplies
221 Oxford Street
Darlinghurst
NSW 2010

Will's Quills
164 Victoria Avenue
Chatswood
NSW 2067

Eckersley's
116–26 Commercial Road
Prahran
Victoria 3181

Art Papers & Supplies
243 Sterling Highway
Claremont
Western Australia 6010

Jackson's Drawing Supplies
103 Rokeby Road
Subiaco
Western Australia 6008

Eckersley's
21 Frome Street
Adelaide
South Australia 5000

Oxlades Paint and Art Centre
136 Wickham Street
Fortitude Valley
Queensland 4006

Art Requirements
1 Dickson Street
Wooloowin
Queensland 4030

2 Art
161 Elizabeth Street
Brisbane
Queensland 4000

Artery
31 Davey Street
Hobart
Tasmania 7000

Phillip Craft Supplies
53 Colbee Court
Phillip
ACT 2606

Index